BETH VAN HOESEN
The Observant Eye

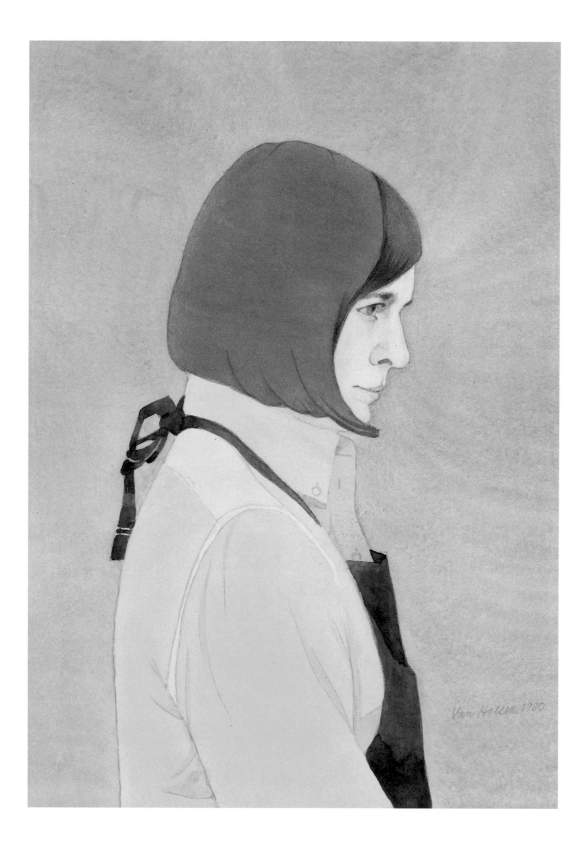

Van Hohen, 1980

BETH VAN HOESEN
The Observant Eye

Joseph Goldyne

Bob Hicks

Fresno Art Museum, California

University Museums, Iowa State University, Ames

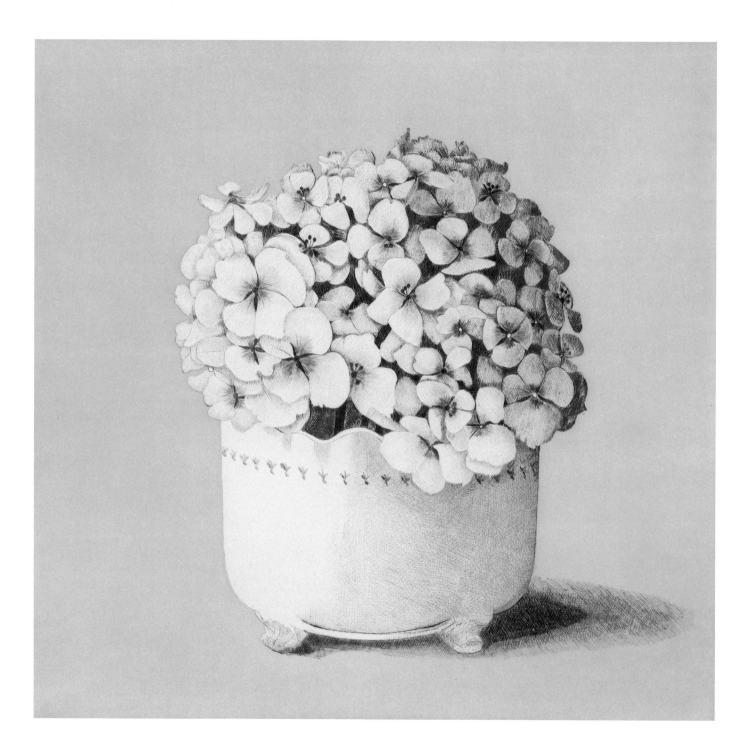

Contents

Foreword

Beth Van Hoesen has her way with line.... One might say that Dürer would have understood and approved, but one might equally compare it with Picasso. However, any comparison would only serve to point out the individuality that is here before us. Here is a style, and also an approach to subject matter so sensitive and intimate, and yet so direct and natural, that the artist need not use a signature to mark her works.

—E. Gunter Troche, 1961

The words quoted above by my predecessor at the Achenbach Foundation for Graphic Arts are evidence that the admiration for the art of Beth Van Hoesen began over forty years ago and has continued unabated to the present day. Other talented artists during this time have burst like fireworks upon the art world of the Bay Area only to momentarily glow brightly and then quickly dim. Van Hoesen has had her graphic art shine like a steady glowing beacon over the years. Her art has grown and become increasingly rich and complex in its subject matter and color. This growth has come about through the methodical development and increased confidence of the artist, not through any outside pressures to succeed or be accepted.

Her art is based on line; it is the most direct, and also one of the most difficult ways to convey ideas artistically. In line, there is no place to hide. Her compositions are straightforward and, although carefully composed, still obtain a sense of spontaneity. Pleasing surface effects are not her purpose; composition, distillation of subject matter to its essential structure and insight into personality are her purpose.

Robert Flynn Johnson, 1983
Curator Emeritus
Achenbach Foundation for Graphic Arts
Fine Arts Museums of San Francisco

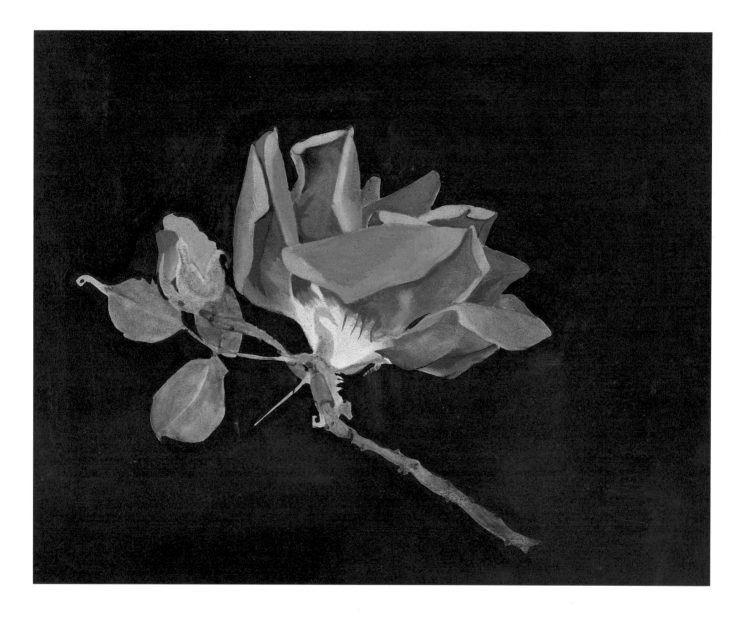

Bob Hicks

Discovering the Hidden Sublime in the Ordinary

The art world worships bigness, whether in actual dimensions or the audacity of ideas—the Sistine Chapel, Richard Serra's *Tilted Arc,* Damien Hirst's sliced-up sharks and cows, Rene Magritte's pipe that is not a pipe.

But another tradition takes a contrarian's view, and its roots go back at least as far as the landscapes, still lifes and nature studies of the Old Masters.

This tradition, if it bothered to post a manifesto, would state simply that the subject of art is all around us, in the images and encounters of the everyday, and that the object of the artist is to see, truly see, the world of small things and reach into its ordinariness to discover the hidden sublime. Think Albrecht Dürer's young hare, or Henri Matisse's decorated rooms, or the Dutch painter Ambrosius Bosschaert's vivid flowers.

Beth Van Hoesen, a San Francisco artist who was born in Boise, Idaho, in 1926, is an exemplar of the latter view. In a career that's been long and fruitful if only modestly acclaimed, she's filled the world with seemingly simple images that create a kind of mosaic of the wonderfully ordinary and the quietly exotic.

Nudes, portraits, animals, flowers, vegetables, landscapes, all of which she's rendered in sure-lined drawings and intaglio prints since the mid-1950s, celebrate the acuity and pleasures of the eye that is attuned to the beauty of the measured life.

Velvet Rose, 1982

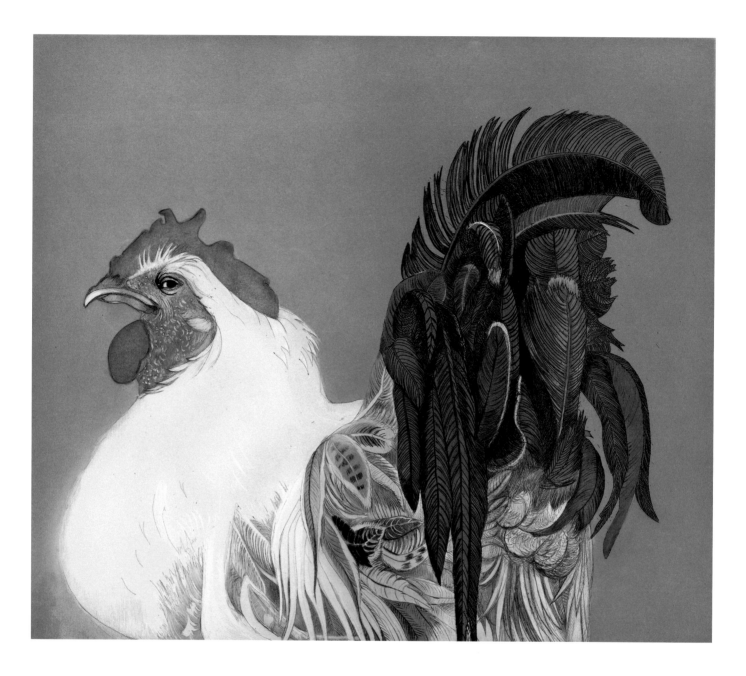

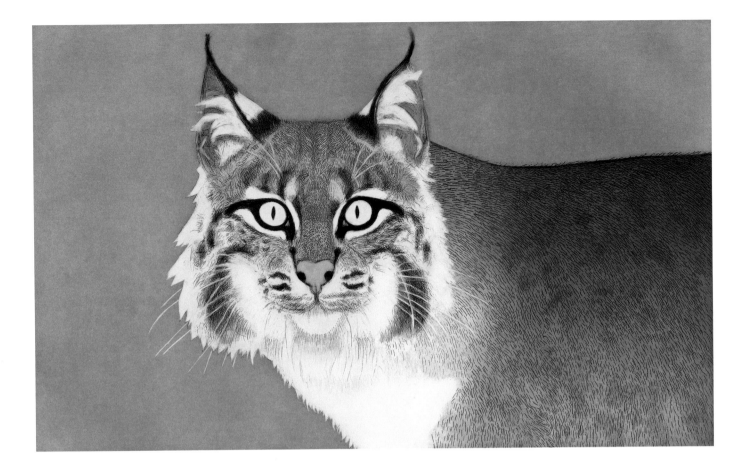

This is not earth-shattering—that's not the nature of Van Hoesen's work—but it's immensely pleasing, and that *is* the nature of Van Hoesen's work. It reminds you that skill, execution and generosity of spirit are still vital aspects of the artistic trade. An exhibit that can veer on first glance toward the sentimental and merely decorative, especially in its animal portraits, takes on a more steely perspective when you start to pay stricter attention.

Let's take those animals, several of which have names: Rufus the bobcat, Boris the rooster, Sally the rabbit, Bugs the cat. There is, first, an anatomical precision (often with details dropped out so other details will pop), but beyond that, a defining personality. It's anthropomorphic, but there also is a fierce defining intelligence that comes through in the eyes, which in Boris's case are cast askance, and crotchety, and slightly challenging. You can see that in some of the portraits of people too.

Bobcat (Rufus)
(2ND STATE), 1986

OPPOSITE
Boris, 1981

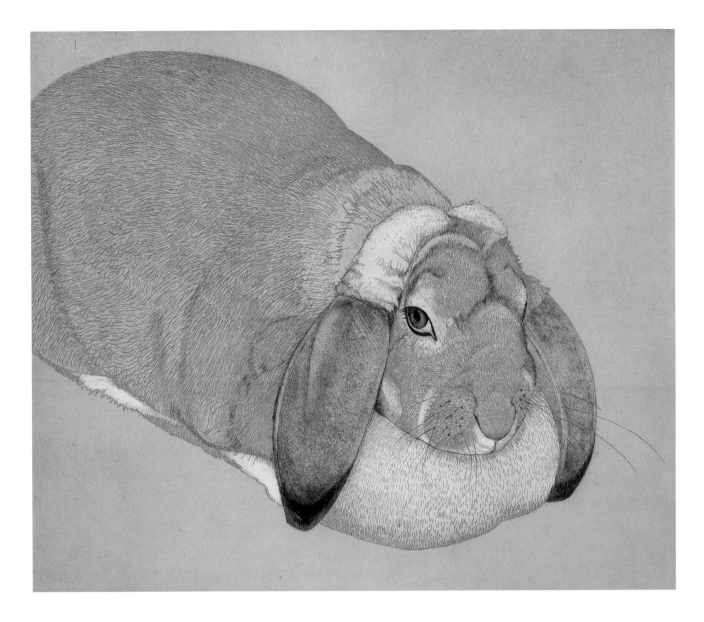

Sally, 1979/80

OPPOSITE
Bugs, 1985

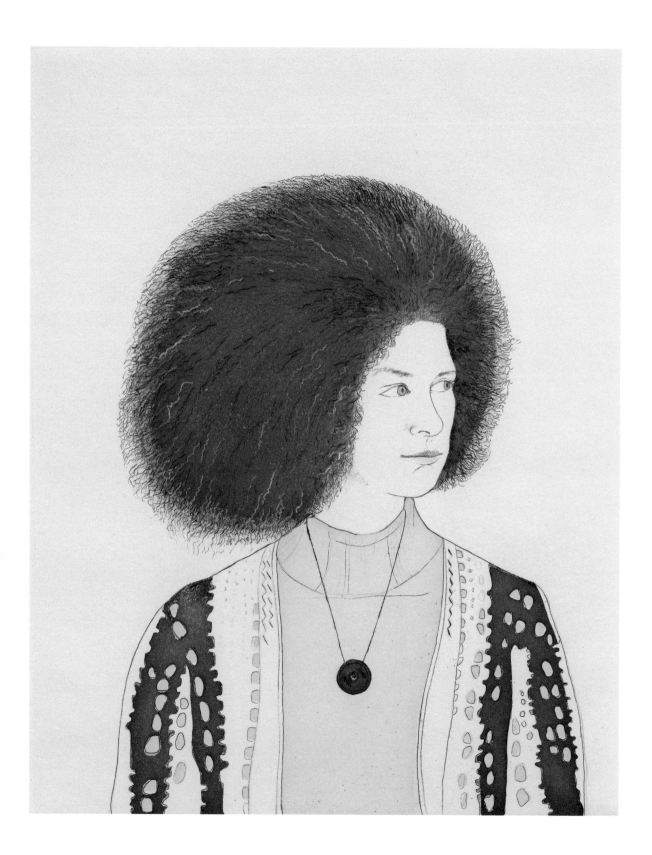

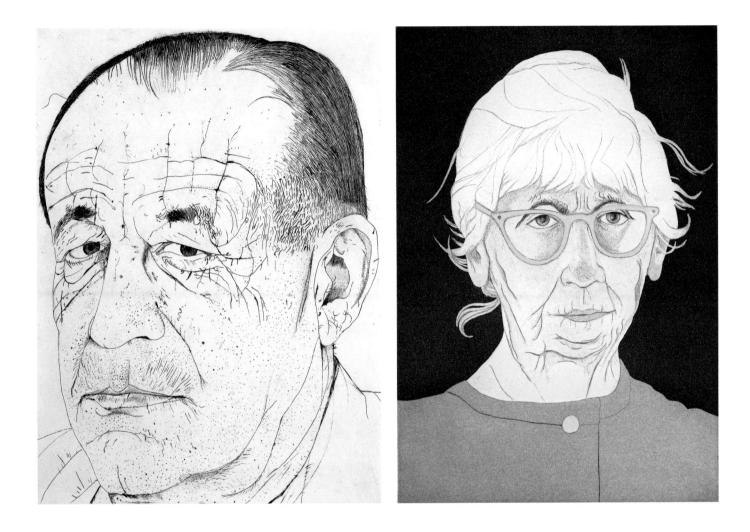

The portraits range from a black-and-white rendering of her father in his autumn years, strong and craggy with a droop of decay below his eyes, to vibrant images of women friends (including Imogen Cunningham) with emphatic splashes of lipstick or frizzy crowns of red-orange hair. Two prints of tattooed men—one, from 1966, whose body is covered but whose neck and head are corporate-responsible; the other, from 1990, of a guy with a Mohawk and a spider skull along his jaw line—speak tellingly of their respective times.

LEFT
Enderse (E. G.), 1965

RIGHT
Imogen (2ND STATE), 1984

OPPOSITE
Pat, 1972

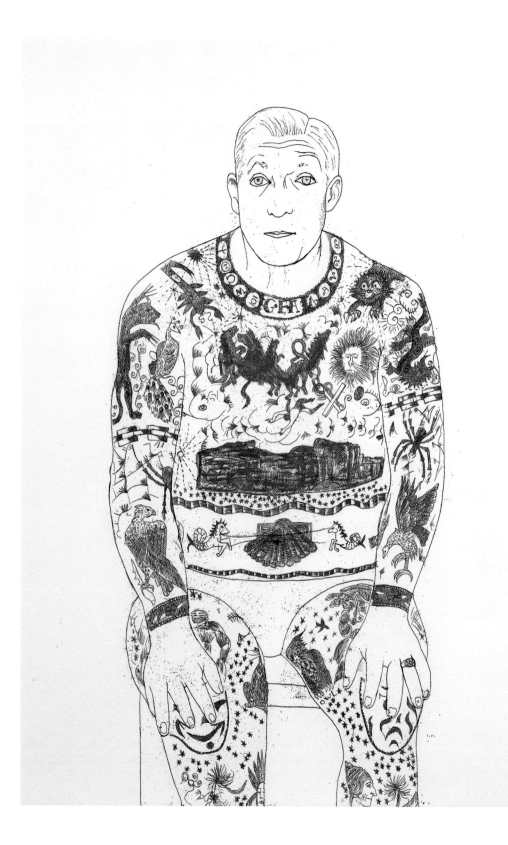

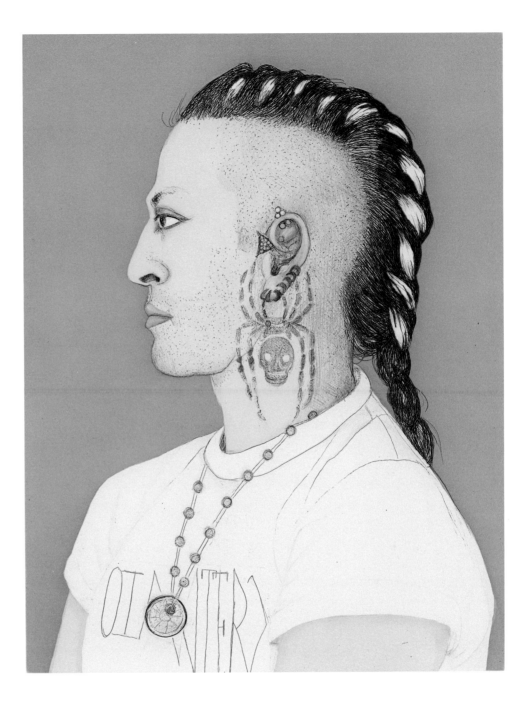

Steve, 1990

OPPOSITE
Tattooed Man, 1966

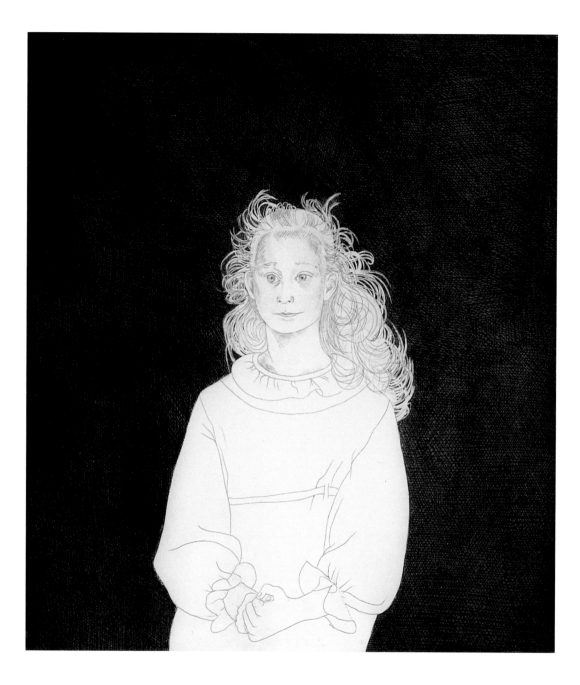

Erika, 1966

OPPOSITE
Poppy in Hand, 1976

10

Then there's the etching and aquatint *Erika,* from 1966, an oddly compelling piece that has an otherworldly, faerie quality. Erika is barely sketched in, with wide eyes, placid jaw, long tangled hair and a black background that isn't negative space at all: it's alive with lines that shoot away from her like an untinted aurora, pushing her, ghostlike, to the foreground.

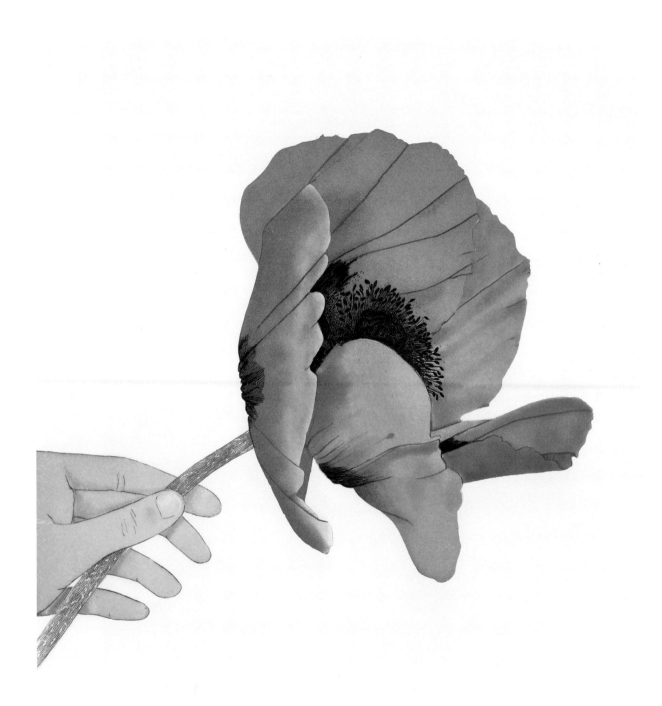

Van Hoesen's flowers are lush and richly colored and a little reminiscent of Georgia O'Keeffe's but without the sexual metaphor; they seem more specifically about flowerness.

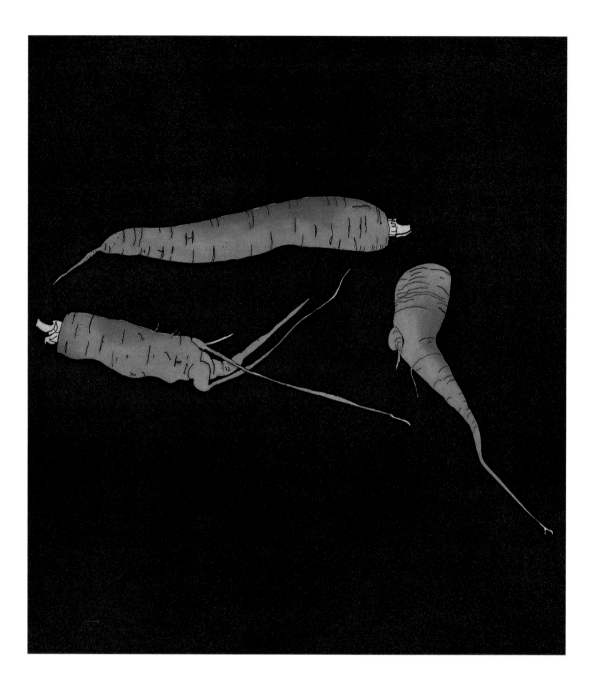

Other pieces emphasize the technical precision of Van Hoesen's work: elegant miniatures of a bee and a beetle; intriguingly warped carrots; leeks that seem to be dancing on their stalks. You can get lost inside a drypoint of a head of lettuce, which seems to contain a wooded landscape, with Hokusai sea-waves at the leaves' edges.

Carrots, 1973

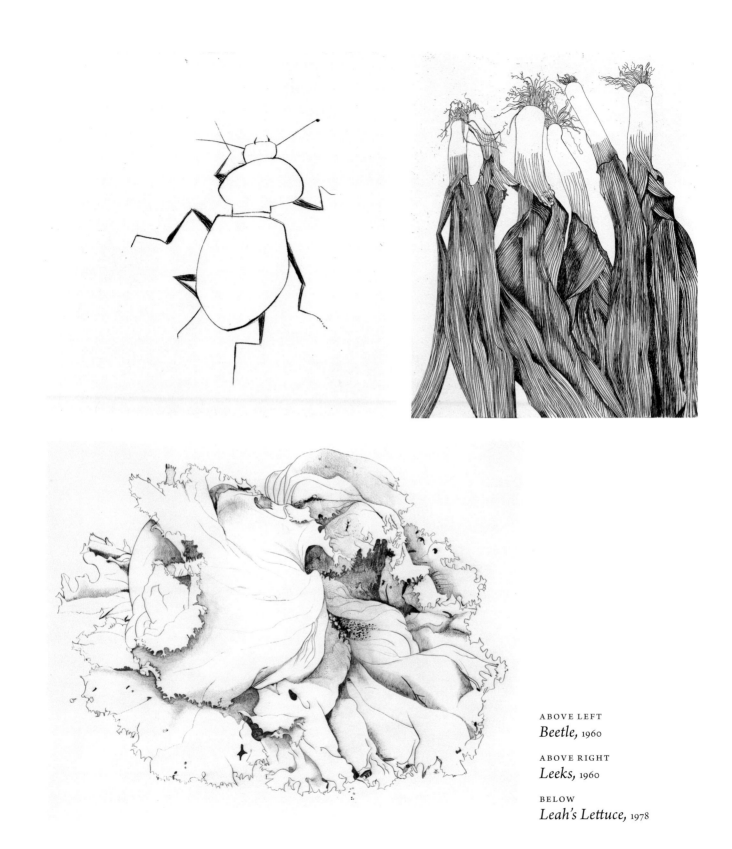

ABOVE LEFT
Beetle, 1960

ABOVE RIGHT
Leeks, 1960

BELOW
Leah's Lettuce, 1978

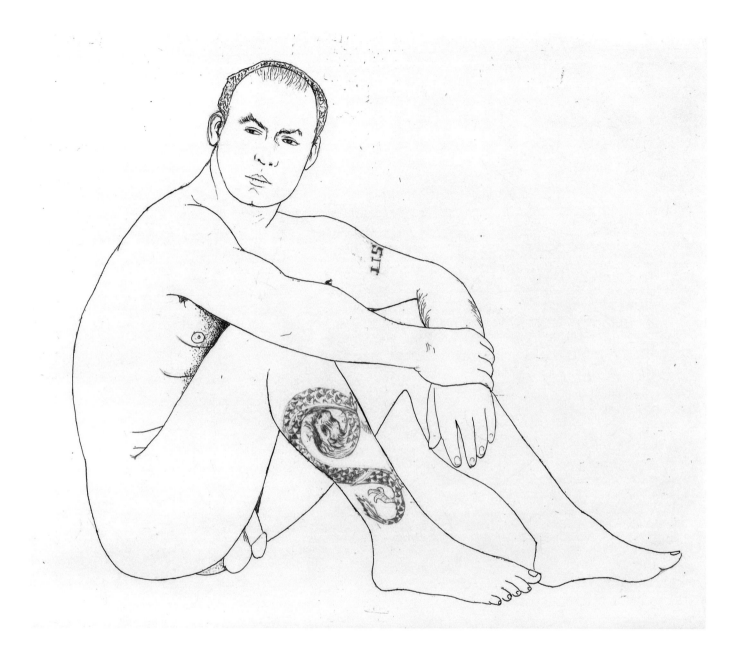

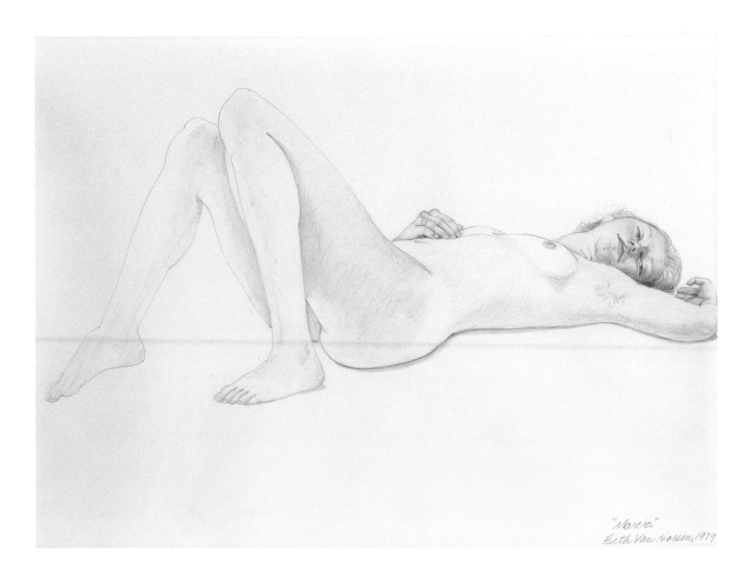

"Marcia"
Beth Van Hoesen, 1979

The male nudes are matter-of-fact, full-frontal, legs parted; one of Van Hoesen's teachers, the artist David Park, taught her "to pay attention to the spaces between the limbs of the body." They are black and white. The women nudes, by contrast, are in color, and more discreet, with poses that suggest a secret modesty.

Van Hoesen isn't well-known away from the West Coast, but she was well aware of the currents in the broader art world. She's always done what she wanted to do—in her own small, well-observed way.

Marcia, 1979

OPPOSITE
Tattoo (PRINT NO. 23
FROM *THE NUDE MAN*), 1965

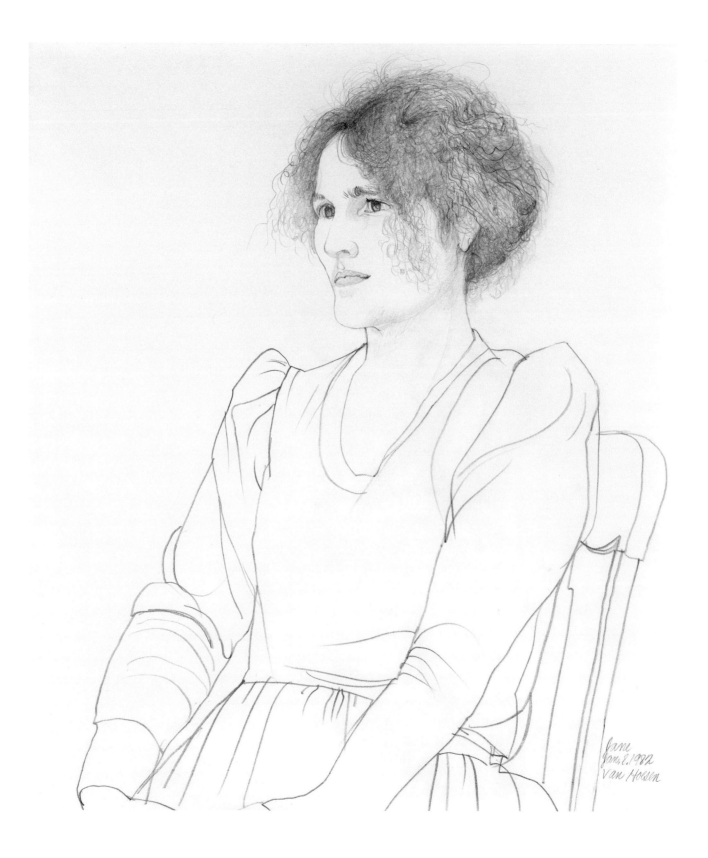

Jane
Jan. 8, 1982
Van Hoesen

Joseph Goldyne

Committed to the Line:
Prints and Drawings by Beth Van Hoesen

Though for the most part Beth Van Hoesen's best-known subjects are very appealing and do not challenge propriety, the fact that a considerable number of her artworks are especially memorable forces the question: just what is it that she does so well? Several things, to be sure, but the answer is not so easy as it first may seem. Most of the artist's subjects are people and animals. Removed from their frames and scattered on a table to lessen their exhibition-necessitated isolation, we instantly recognize in all of these 'beings' a uniquely pared-down style of drawing—of the sort that one may claim tells us more than it asks of us. That is because Van Hoesen's prints are her very well-planned final statements (i.e., final drawings) on her chosen subjects.

Plenty of 'asking,' however, occurs in the artist's preparatory drawings. These drawings are wonderful 'visits' with her subjects; in them, the artist interrogates their form, their stance and glance, and (in the best of her sheets) their character. It is true that being addressed by these preparatory efforts differs from the effect of the finished prints, for the prints are the equivalent of paintings—that is, they have often been the ultimate goal of her efforts, despite the remarkable success of her preparatory studies in and of themselves. Naturally, not all of the artist's drawings were destined to inspire prints. For Van Hoesen, as for many gifted draftsmen, drawing has been akin to breathing. It is just something she has always done, what all her looking has led to, and her body of drawings alone would be more than sufficient to give her prominence in her period and among her peers.

Jane, 1982

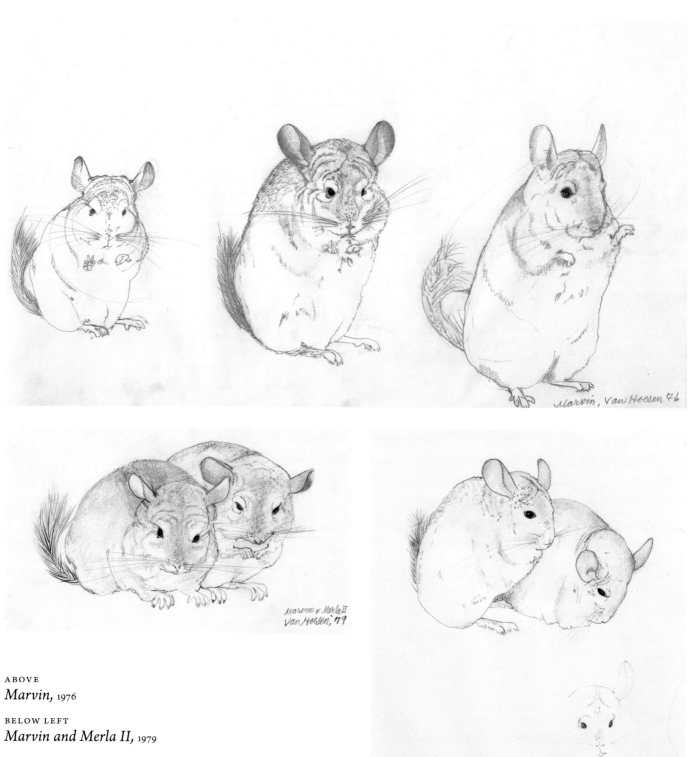

ABOVE
Marvin, 1976

BELOW LEFT
Marvin and Merla II, 1979

BELOW RIGHT
Marvin and Merla I, 1975

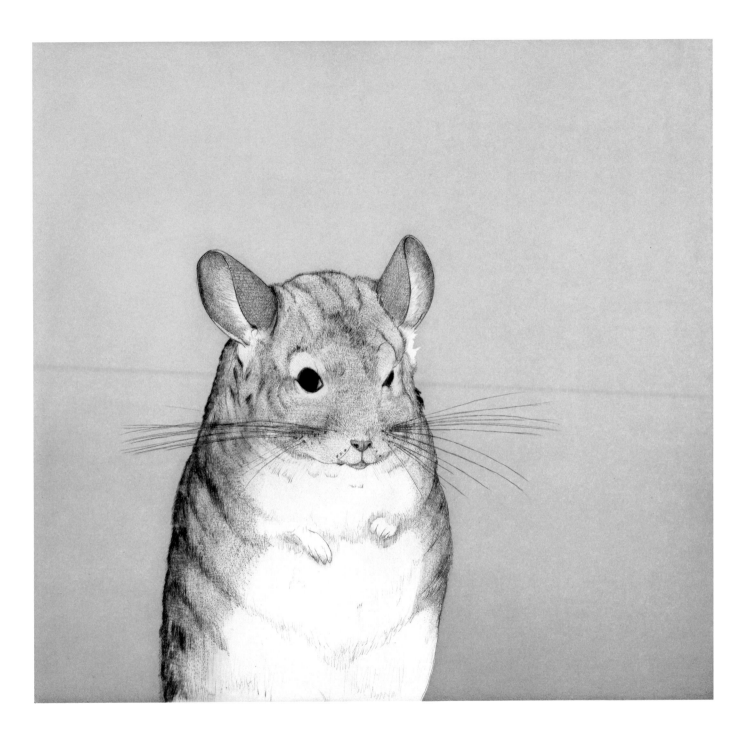

Marvin C., 1979

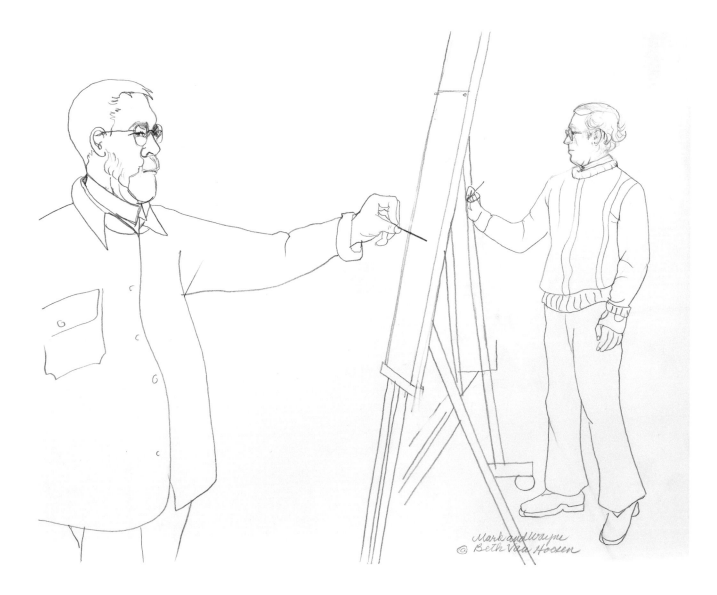

Mark and Wayne, c. 1977

OPPOSITE
Drawing Session II, 1980,
1980

A drawing style tells the careful observer as much about what an artist is looking for as it does about what he or she is looking at. For years, Van Hoesen participated in a small weekly drawing group, the members of which included her husband Mark Adams, Theophilus Brown, Gordon Cook, Wayne Thiebaud, and Paul Wonner, as well as Robert Bechtle, Timothy Berry, Patricia Wall, Stanley Washburn, and other artists. Friends and models would pose for them. To look at Beth Van Hoesen's sheets from these sessions provides ample evidence of her focus on clarifying form by rigorously observing the curves and relationships specific to her sitters.

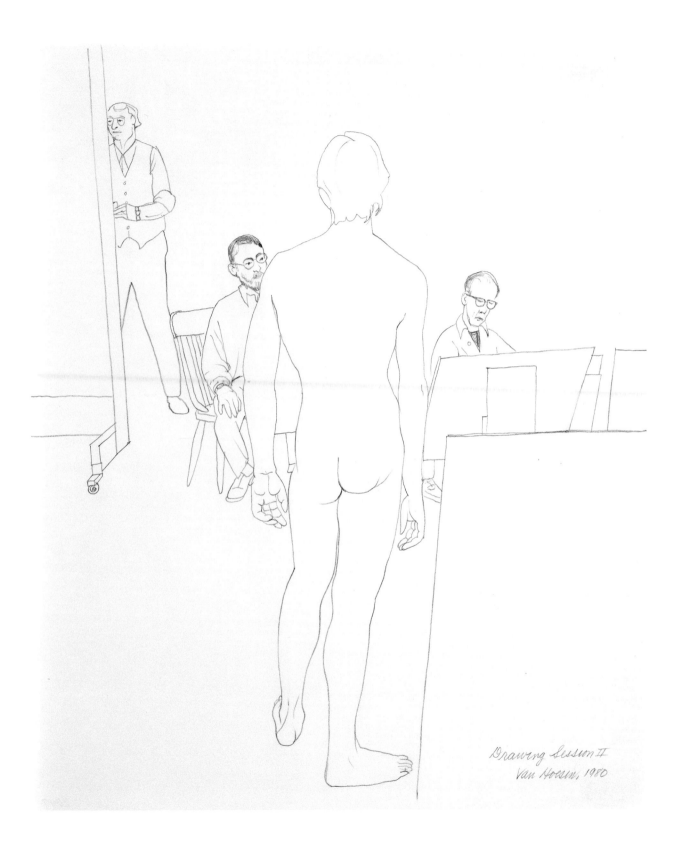

Drawing Session II
Van Hoesen, 1980

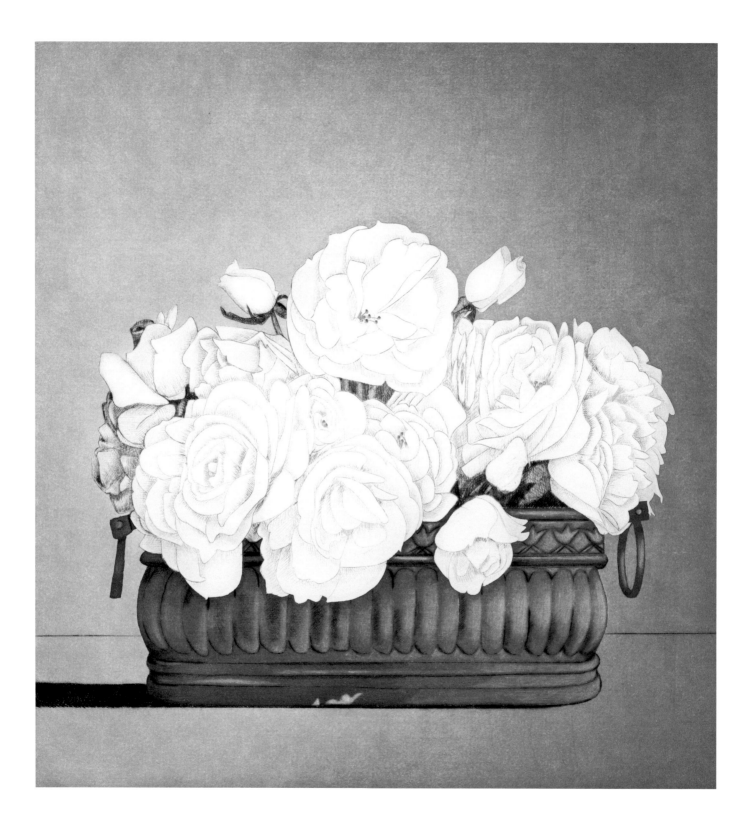

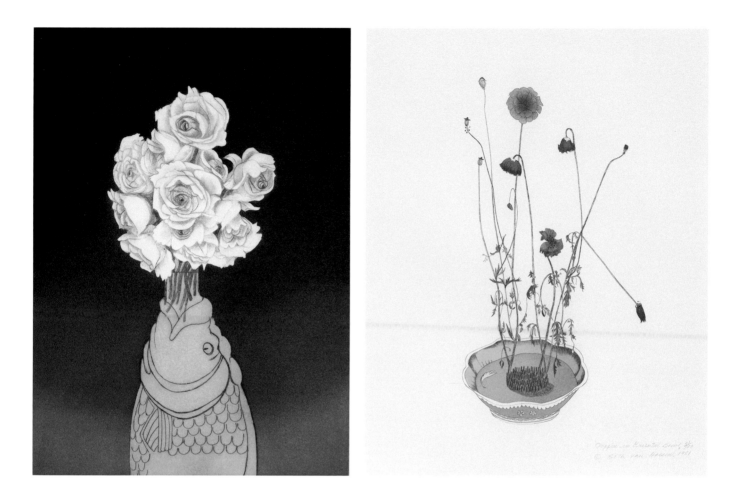

As was Mary Cassatt in the nineteenth century, Beth Van Hoesen has been a serious technician, a fastidious and demanding partner of printers who were often frankly stumped by "just what Beth really wanted." Often the answer was an almost ineffable, perhaps even unattainable subtlety. In fact, it may be that what she sometimes wished for was not achieved, but as she worked obsessively with the best printers imaginable, the effort to attain the unattainable certainly made the prints more successful. Beth Van Hoesen was also highly competent as a printer in her own right, but she usually limited her hands-on participation to the proofing process—the trial-and-error inking of the plate and pulling of impressions to explore the range of possibilities inherent in an etching plate— before giving it to the printer for editioning.

LEFT
Fish Vase, 1984

RIGHT
Poppies in Oriental Bowl, 1981

OPPOSITE
Karen's Roses, 1980

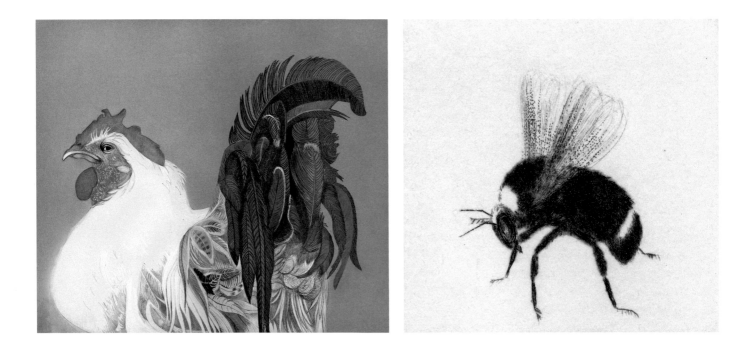

Of Van Hoesen's editions, two very different compositions can serve to illuminate her accomplishment. The rooster *Boris* displays rococo tail feathers delineated as if they were a flower arrangement, and the wings of the little *Bee* are forever beating because of the magic touch of drypoint that ever so slightly blurs form. When one looks at some of Van Hoesen's more reproduced images, in particular her imposing animals, whose often delightfully sinister glances are offset by a svelte draftsmanship that envelops them in a veil of charm, one confronts the problem that has perhaps hindered a greater, more nuanced understanding of her work: the very accessibility of much of it. To be sure, the aesthetic tarnish often associated with accessibility can be deserved, particularly when it claims support for work that is simply mediocre, but dismisses regard for art that is exploratory and conducted with considerable conviction.

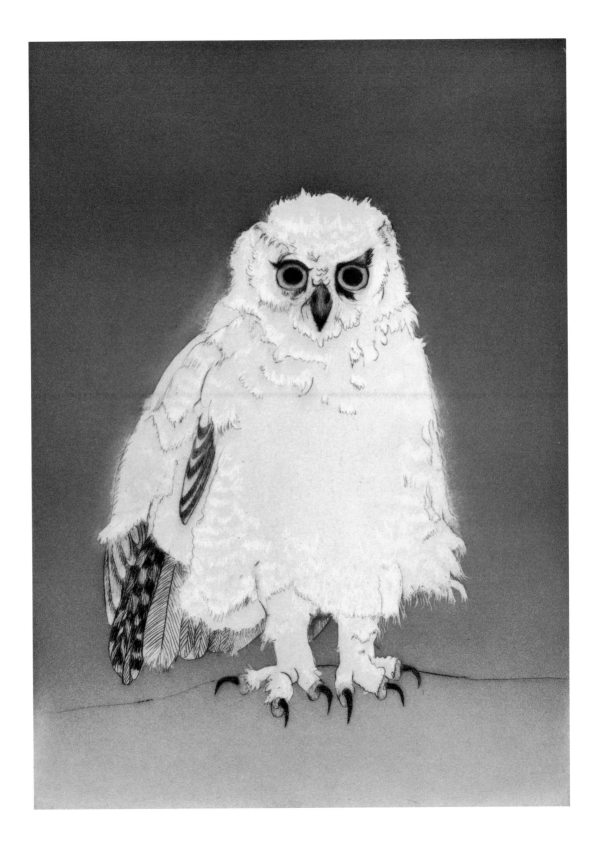

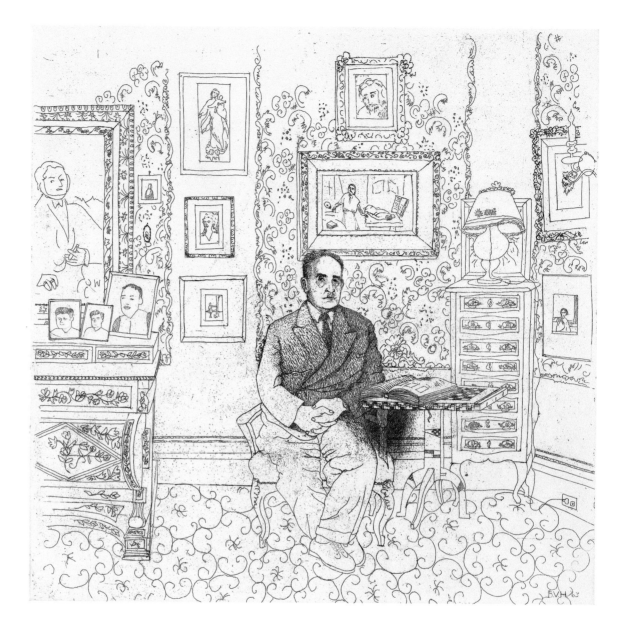

We too often forget, however, that accessibility can also be the result of very good art reflective of its times. Raphael, Albrecht Dürer, Guido Reni, Velázquez, Rubens, Canaletto, Corot, Winslow Homer, Edward Hopper, and Georgia O'Keeffe were all superior artists whose works were considered accessible during their lifetimes. Their art was either documentary or romantic to the point of ideality, but in every case, factors including beauty, timeliness, and technical superiority contributed to their allure.

Unlike the eminent artists cited above, Van Hoesen has mostly limited her work to printmaking and drawing, but she has addressed subjects that have universal appeal or are topically edgy—most often, the human body, animals, and flowers. As principals and extras, gods and pets, robust and frail, we all appreciate that animal and human bodies have been drafted into the service of artists for millennia, becoming the Everyman of art. Whether on cave walls, sketchbook sheets, or etched plates, rendering the living form provided for artistic self-testing, and professionals have as often embraced the challenge as students have run from its common pitfalls. Ubiquitous as are such studies, however, the truly distinguished capture of the human or animal presence on a two-dimensional surface remains a really rare event. In truth, sculptural renditions of such subjects have in general been more successful in their frequency of attaining truly memorable interpretations.

Dazzle, 1985

OPPOSITE
The Collector, 1963

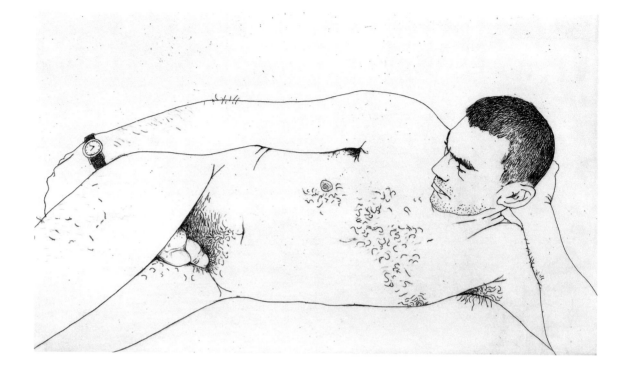

From Van Hoesen's first major etched body of work, a Crown Point Press artist's book of 1965, consisting of twenty-five etchings and engravings, and titled *The Nude Man,* she has created distinguished work and has come to be one of California's better-known artists. *The Nude Man* was one of the four earliest artists' publications produced by the esteemed Crown Point Press, along with *Poems* by Judson Jerome with etchings by Kathan Brown (1964); Richard Diebenkorn's *41 Etchings* (1965); and Wayne Thiebaud's *Seventeen Delights* (1965). As the work of a young woman treating the unidealized male nude, Van Hoesen's effort was not exactly embraced by those who later came to eagerly await her publications of animals and flowers.

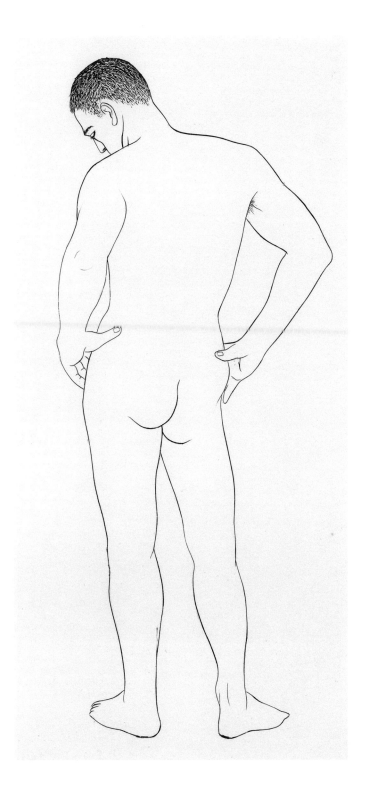
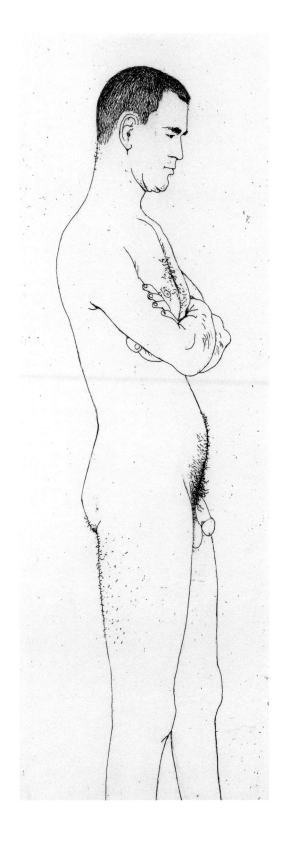

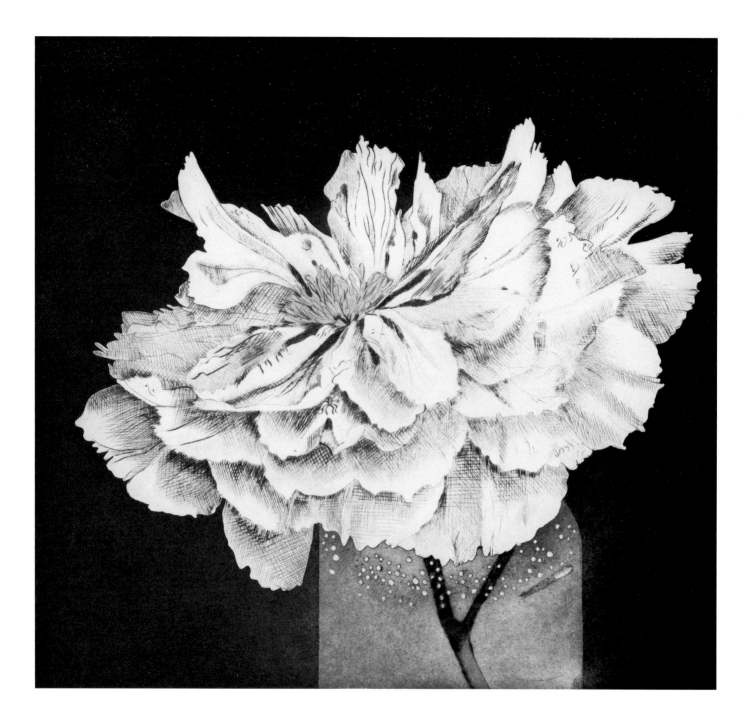

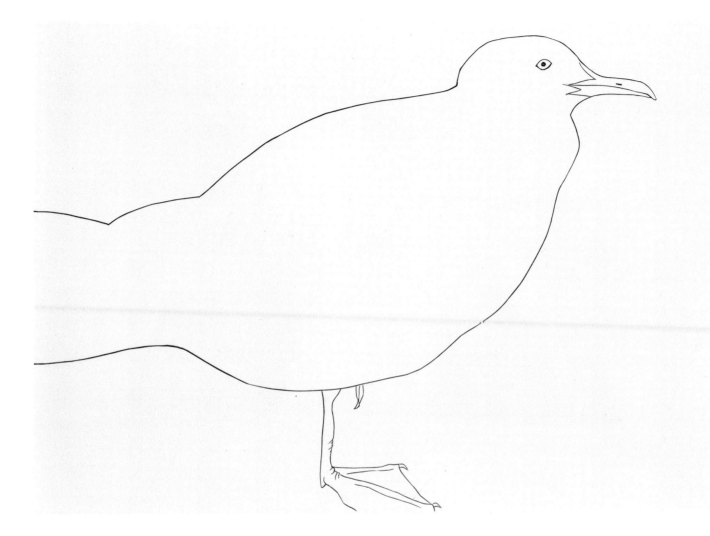

Van Hoesen's career surprises us, though, in its understanding that radical and conservative are often shifting positions in a dance done around, rather than by, an artist. For her, the appeal of a subject owed largely to its adaptability to intaglio recording—how it would comport with her love of capturing the essence of form in line and tone. Focusing on graphic media, Beth Van Hoesen evolved a style that simplified her presentations more than it complicated them. This owes not to lack of ambition, but rather, to a recognition that a health (arthritic) condition as well as a penchant for the 'feel' of graphic work conspired to offer her what was actually a perfect stage for her intimate art.

Gull (Seagull), 1963

OPPOSITE
Greta's Peony, 1976

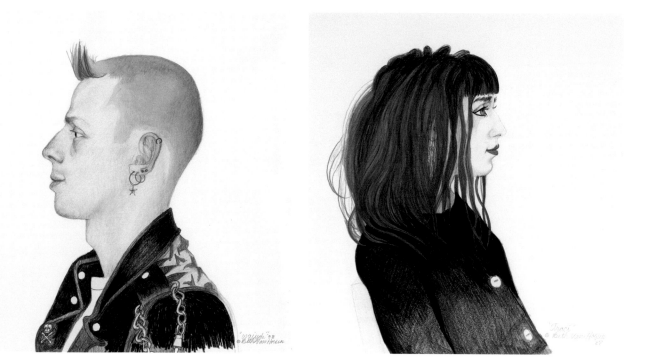

LEFT
Waiyde, 1988

RIGHT
Traci, 1988

OPPOSITE
Traci, 1990

32

Van Hoesen's legacy of drawing the nude as well as her portrait prints has included a little-known and quite remarkable series of drawings and prints capturing the punk culture in her old San Francisco neighborhood: young men and women with tattoos, piercings, and wild hair. These exotic human creatures fascinated the artist just as much as did her better-known birds and beasts. Van Hoesen accepted and recorded as a feast of color and form their 'plumage' that was meant to shock the average observer. If the floral subjects of a few of Van Hoesen's prints seem to be overly saturated with color, the punks seem to revel in it.

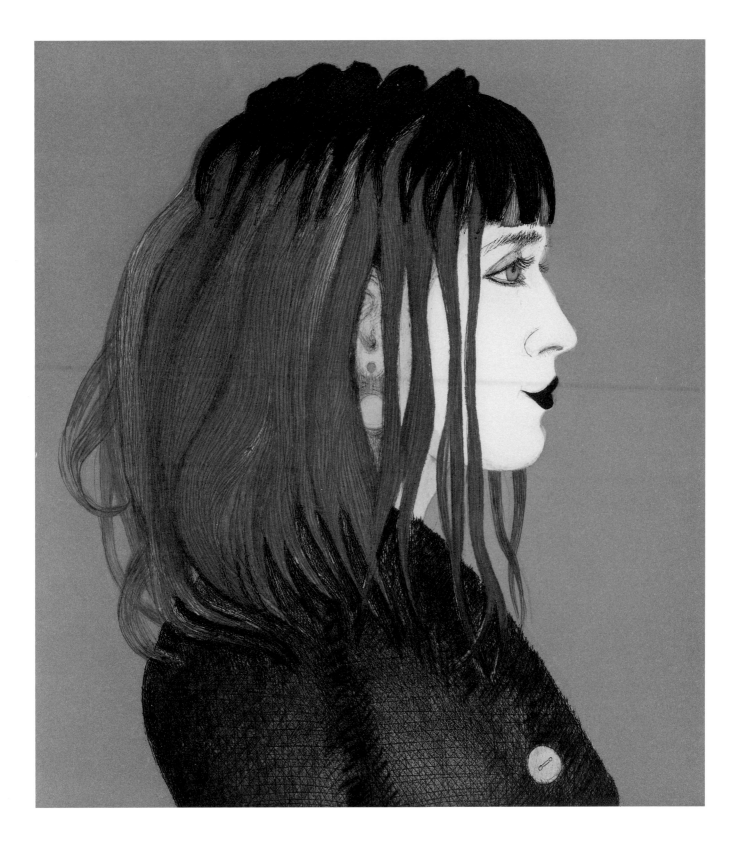

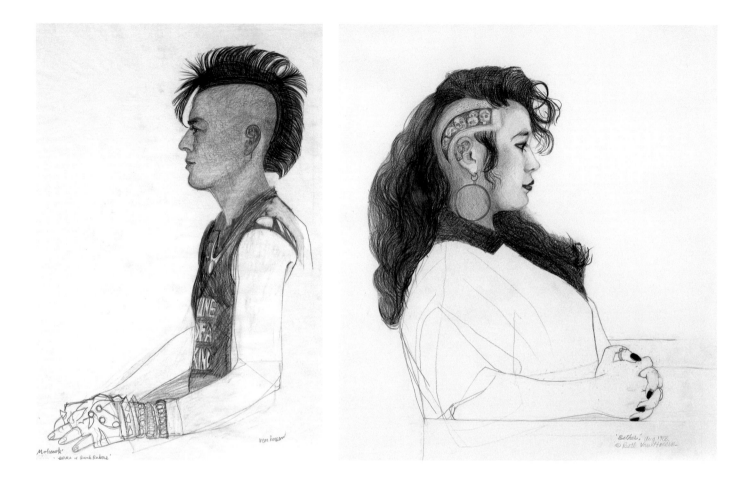

LEFT
Mohawk, c. 1988

RIGHT
Esther, 1988

OPPOSITE
Billy, 1988

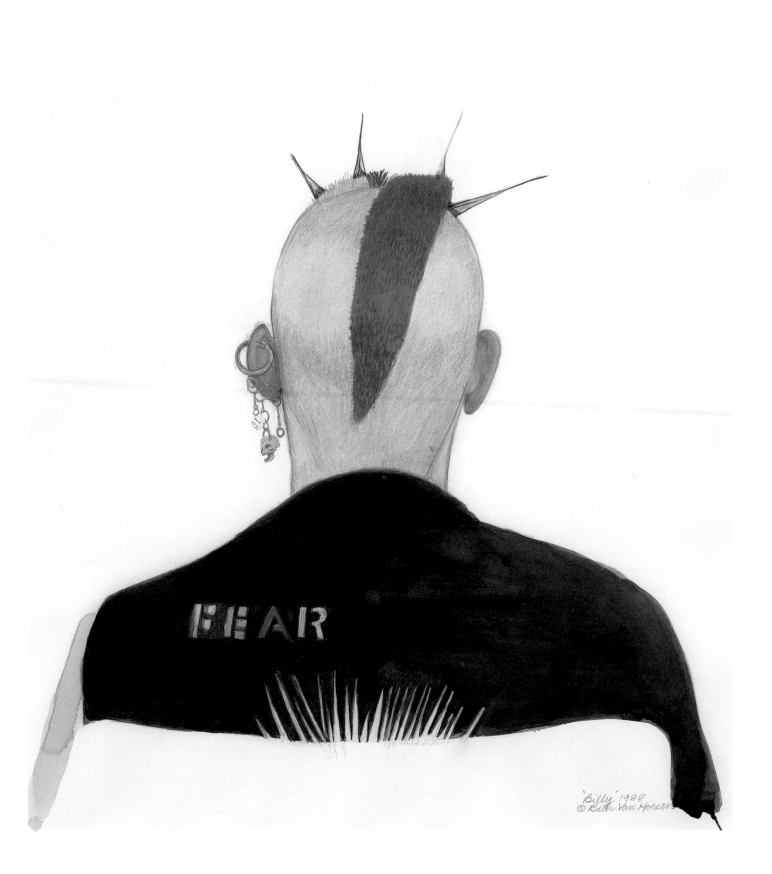

'Billy' 1988
© Beth Van Hoesen

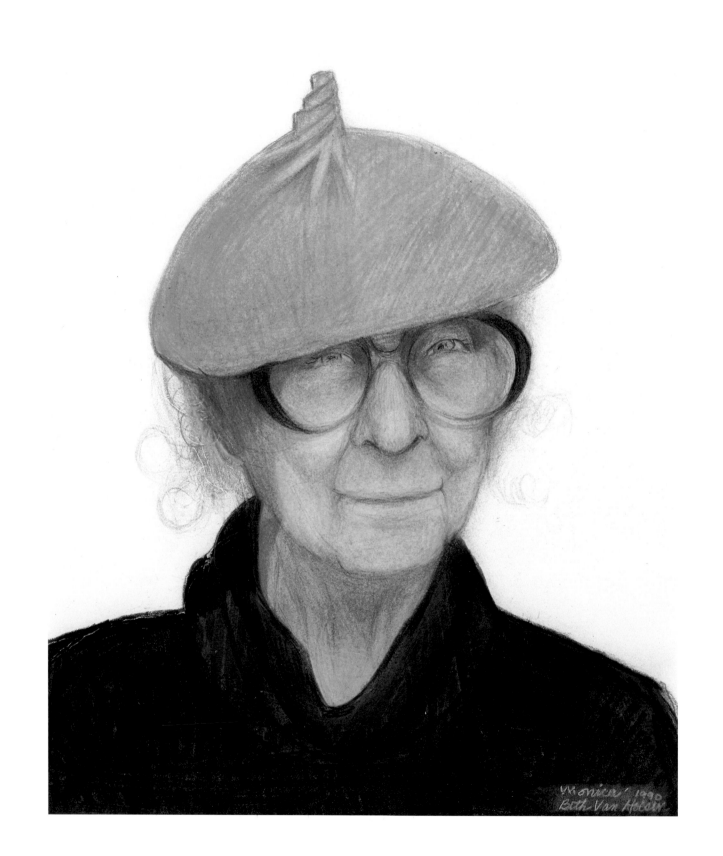

Monica 1990
Beth Van Hoesen

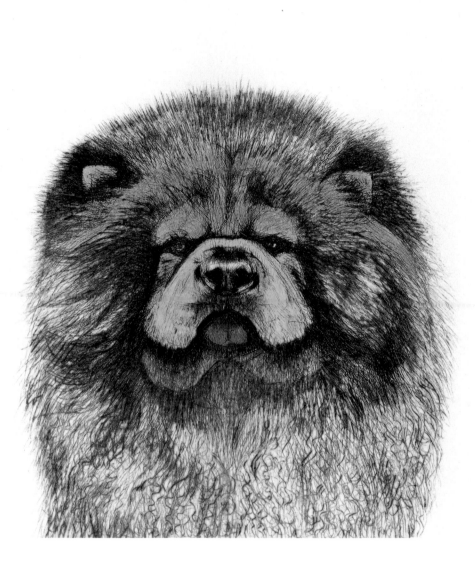

Together with her floral and animal compositions, Beth Van Hoesen's drawings and prints of friends and models comprise the vast majority of her work. It is work that loves its subjects, but that also deeply respects the traditions of the media through which they are expressed. As a result, Beth Van Hoesen's art is more than comfortable with its mastery. Our eyes, never harangued, are instead invited to follow line, mass, and color that enjoy seemingly perfect placement and resolution.

Chow, 1985

OPPOSITE
Monica, 1990

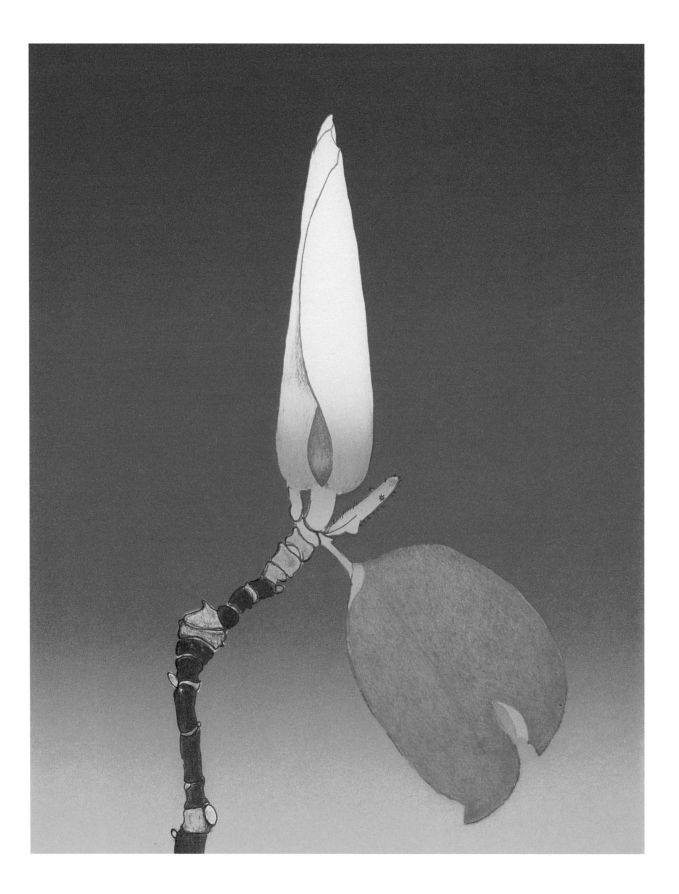

Exhibition Checklist

1960

Beetle, 1960
Engraving
Image: 3 × 2¾ inches
Page 13, above left

Leeks, 1960
Engraving and etching with drypoint and roulette
Image: 9¾ × 8 inches
Page 13, above right

1963

Gull (Seagull), 1963
Engraving
Image: 8¼ × 12 inches
Page 31

1965

Enderse (E. G.), 1965
Etching and drypoint with roulette
Image: 14¾ × 11⅛ inches
Page 7, left

1966

Erika, 1966
Etching with roulette and aquatint printed in black ink
Image: 15¾ × 14¼ inches
Page 10

Tattooed Man, 1966
Etching with roulette printed in blue and black inks, handcolored with watercolor
Image: 15¼ × 11¼ inches
Page 8

1972

Judy, 1972
Aquatint and drypoint with roulette printed in burgundy, black, and tan inks
Image: 16¼ × 13⅛ inches
Page 44

Pat, 1972
Aquatint, etching, and drypoint with roulette printed in red-orange, black, and yellow-beige inks
Image: 11 × 9 inches
Page 6

1976

Aegean Poppies, 1976
Aquatint and etching printed in green, black, and red inks, handcolored with watercolor
Image: 15¼ × 14⅝ inches

Greta's Peony, 1976
Aquatint and drypoint printed in blue and red inks, handcolored with watercolor
Image: 10¾ × 11½ inches
Page 30

Little Poppies, 1976
Aquatint and etching with drypoint printed in cadmium yellow and black inks à la poupée, handcolored with watercolor
Image: 10½ × 10¾ inches

Matilija Poppy, 1976
Aquatint and drypoint printed in light green, dark green, and dark blue inks
Image: 13⅝ × 12 inches

Peony, 1975/76
Aquatint, engraving, etching, and
drypoint with roulette printed in black,
green, and red inks
Image: 17⅜ × 14⅛ inches

Poppy in Hand, 1976
Aquatint, etching, and drypoint printed
in green, brown, red-orange, orange,
and dark blue inks, handcolored with
watercolor
Image: 14¾ × 13⅞ inches
Page 11

1977
Magnolia Bud, 1977
Lithograph
14 × 11 inches
Page 38

1978
Ingrid, 1978
Aquatint, etching, and drypoint printed
in reddish-brown, black, red, and brown
inks, handcolored with watercolor
Image: 13¾ × 10⅞ inches
Page vi

Lea's Lettuce, 1978
Drypoint with roulette
Image: 13¾ × 17¾ inches
Page 13, below

1979
Bowl of Hydrangeas, 1979
Color aquatint and hardground with
drypoint
Image: 13½ × 13⅞ inches
Page iv

Coxon Belleek with Rose, 1979
Drypoint with roulette printed à la
poupée in red, pink, brown, and violet
inks, handcolored with watercolor
Image: 5½ × 5⅞ inches

Fly, 1979
Drypoint, handcolored with watercolor
Image: 1⅞ × 1¾ inches

Marcia, 1979
Colored pencil and graphite on paper
11¼ × 15½ inches
Page 15

Marvin C., 1979
Aquatint and drypoint with roulette
printed in black and purple-brown inks
Image: 10¼ × 10⅞ inches
Page 19

Mirror, 1979
Etching and aquatint
Image: 14⅞ × 22⅜ inches
Back cover

Royal Crown Darby with Daisy, 1979
Drypoint printed à la poupée in olive-
green and blue inks, handcolored
with watercolor
Image: 5½ × 5⅞ inches

Sally (STAGE I), 1979
Aquatint, drypoint, and etching with
roulette, with graphite additions
Image: 11¾ × 13¾ inches

Sally (STAGE III), 1979
Drypoint and etching with roulette
Image: 11¾ × 13¾ inches

Sally (STAGE V), 1979
Aquatint, drypoint, and etching with
roulette
Image: 11¾ × 13¾ inches

Sally (STAGE VI), 1979
Aquatint, drypoint, and etching with
roulette printed in black-brown and black
inks, with à la poupée inking in light
brown, black, yellow ochre, and rust, with
burnishing and scraping
Image: 11¾ × 13¾ inches

Sally (STAGE X, GUIDE PROOF,
BEFORE FACING), 1979
Aquatint, drypoint, and etching with
roulette printed in black-brown and
black inks, with à la poupée inking in
light brown, black, yellow ochre, and
rust, with burnishing and scraping
Image: 11¾ × 13¾ inches

Sally (STAGE XIII, AFTER STEEL FACING),
1979
Aquatint, drypoint, and etching with
roulette printed in black-brown and black
inks, with à la poupée inking in light
brown, black, yellow ochre, and rust,
with burnishing and scraping
Image: 11¾ × 13¾ inches

1980
Dr. R's Skull (2ND STATE), 1980
Aquatint and drypoint printed in olive
green ink, handcolored with watercolor
Image: 7¾ × 9⅞ inches

Karen's Roses, 1980
Aquatint and drypoint printed in black,
dark green, and yellow inks, handcolored
with watercolor
Image: 11⅜ × 10⅞ inches
Page 22

Sally, 1979/80
Aquatint, drypoint, and etching with
roulette printed in black-brown and
black inks, with à la poupée inking in
light brown, black, yellow ochre, and
rust, with burnishing and scraping
Image: 11¾ × 13¾ inches
Page 5

Self-Portrait in Apron, 1980
Watercolor on paper
10¾ × 8¾ inches
Page ii

1981
Boris, 1981
Aquatint, etching, and drypoint with
roulette printed in black, brown-red,
olive green, and green inks, with
scraping of the support, handcolored
with watercolor
Image: 15⅜ × 17⅞ inches
Page 2 and Page 24, left

Poppies in Oriental Bowl, 1981
Lithograph printed in 5 colors
20¾ × 16½ inches
Page 23, right

1982
Buster, 1982
Spit-bite aquatint, drypoint, and etching
with roulette and retroussage printed in
brown, black, and slate grey inks, hand-
colored with watercolor
Image: 19⅞ × 17¾ inches

Dürer Can, 1982
Aquatint, drypoint, and etching printed
in red, black, and blue inks, handcolored
with watercolor
Image: 15⅞ × 13¼ inches

Jane, 1982
Graphite on paper
15¾ × 13½ inches
Page 16

Mole, 1982
Aquatint and drypoint, handcolored
with watercolor
Image: 5½ × 7⅛ inches

Owlet, 1982
Aquatint and drypoint with roulette
printed in brown and black inks, hand-
colored with watercolor
Image: 10⅞ × 7¾ inches
Page 25

Suffolk Sheep, 1982
Aquatint and drypoint, handcolored
with watercolor
Image: 13¾ × 16⅞ inches

Sunflower, 1982
Lithograph printed in 8 colors
20¾ × 16½ inches

Velvet Rose, 1982
Oil-based pigments on board
10½ × 13¼ inches
Page viii

Walt Badger, 1982
Lithograph printed in 9 colors
15½ × 15 inches
Page 60

1984
Dr. R's Skull (1ST STATE), 1979/84
Drypoint and aquatint with roulette
Image: 7¾ × 9⅞ inches

Fish Vase, 1984
Aquatint and drypoint printed in olive
green, red, red-brown, and blue inks
Image: 13⅞ × 10 inches
Page 23, left

Imogen (2ND STATE), 1984
Aquatint and drypoint
Image: 8¾ × 6 inches
Page 7, right

1985
Bugs, 1985
Aquatint, etching, and drypoint with
roulette printed in black-brown and
red inks, handcolored with watercolor
Image: 10⅝ × 13¼ inches
Page 4

Chow, 1985
Drypoint printed in red-brown, dark
brown, and black inks, handcolored
with watercolor
Image: 6 × 6 inches
Page 37

Dazzle, 1985
Drypoint with roulette printed in black,
brown and gray-blue inks, handcolored
with watercolor
Image: 11⅛ × 11¾ inches
Page 27

Kewpie, 1985
Aquatint and drypoint printed in
red, blue and black inks
Image: 9¼ × 11 inches

Lily of Noe, 1985
Lithograph
13⅜ × 16 inches

Nasturtiums, 1961/85
Etching and drypoint with roulette
Image: 14⅞ × 18⅜ inches

Sally's Back (Sally II), 1980/85
Drypoint with roulette printed in light
brown, medium brown, dark brown,
and black inks, printed à la poupée
Image: 6¼ × 4¼ inches

Three Iceland Poppies, 1985
Aquatint, hard-ground etching, and
drypoint with burnishing, printed
in black ink with mixtures of orange,
pink, and yellow inks à la poupée,
handcolored with watercolor
Image: 15⅞ × 14½ inches

Two Iris, 1985
Aquatint and drypoint with roulette
printed in black, blue, red-brown, and
yellow inks, handcolored with watercolor
Image: 16⅞ × 13⅞ inches
Front cover

1986
Bobcat (Rufus) (2ND STATE), 1986
Etching, drypoint, and aquatint with
roulette, à la poupée, handcolored
with watercolor
Image: 11⅞ × 19¼ inches
Page 3

1987
Flamingo Drinking, 1987
Linocut printed in black ink
Image: 5 × 4 inches

Flamingo Sleeping, 1987
Aquatint and drypoint with roulette
printed in red, orange, black, blue-green,
olive-brown, and green inks
Image: 13¼ × 11½ inches

Miniature Roses, 1987
Drypoint with roulette printed in orange,
red, and blue inks, handcolored with
watercolor and acrylic pigments
Image: 10⅞ × 7¾ inches

Panther, 1987
Aquatint and drypoint, handcolored
with watercolor
Image: 6⅜ × 5⅝ inches

Three Ducks, 1987
Aquatint and drypoint with scraping,
handcolored with watercolor
Image: 8⅜ × 11⅞ inches

1988
Fuchsia in Hand, 1988
Lithograph printed in 7 colors
12⅝ × 11½ inches

Magnolia in Blue Vase, 1988
Oil-based pigments and varnish
on Foamcore
11½ × 10¾ inches

Park Cyclamen, 1988
Aquatint and drypoint printed in red,
orange, and black inks, handcolored
with watercolor
Image: 11⅝ × 14¼ inches

Pike, 1988
Aquatint and etching with roulette
printed in olive-green and black inks,
handcolored with watercolor
Image: 13¾ × 16⅞ inches

1990
Traci, 1990
Aquatint, drypoint, and hardground
etching with roulette printed in pink,
dark blue, black, and light brown inks,
handcolored with watercolor
Image: 9½ × 8½ inches
Page 33

1992
Flowers, Flowered Vase, 1992
Lithograph printed in 18 colors
22¼ × 17¼ inches

ILLUSTRATED WORKS NOT IN
EXHIBITION

Page 9
Steve, 1990
Aquatint, hardground etching, and
drypoint with roulette printed in black,
blue, gray, and peach inks
Image: 10⅞ × 8½ inches

Page 12
Carrots, 1973
Etching and aquatint, handcolored
with watercolor
Image: 14 × 13 inches

Page 14
Tattoo (PRINT NO. 23 FROM *THE NUDE
MAN*), 1965
Etching and drypoint printed in black
and blue inks
Image: 6 × 7 inches

Page 18
ABOVE
Marvin, 1976
Graphite and colored pencil on paper
9¾ × 16 inches

BELOW LEFT
Marvin and Merla II, 1979
Graphite and colored pencil on paper
18⅝ × 21⅛ inches

BELOW RIGHT
Marvin and Merla I, 1975
Graphite and colored pencil on paper
10 × 9 inches

Page 20
Mark and Wayne, c. 1977
Graphite on paper
14 × 17 inches
Collection of The Oakland Museum

Page 21
Drawing Session II, 1980, 1980
Graphite on paper
17 × 14 inches
Collection of The Oakland Museum

Page 24
RIGHT
Bee, 1967/68
Drypoint, handcolored with watercolor
Image: 2⅛ × 2¼ inches

Page 26
The Collector, 1963
Etching
Image: 11¾ × 11⅞ inches

Page 28
Reclining (PRINT NO. 7 FROM *THE NUDE MAN*), 1965
Etching
Image: 4½ × 7⅜ inches

Page 29
LEFT
Back (PRINT NO. 18 FROM *THE NUDE MAN*), 1965
Engraving
Image: 8¾ × 4 inches

RIGHT
M. Profile (PRINT NO. 10 FROM *THE NUDE MAN*), 1965
Etching
Image: 9⅛ × 3¼ inches

Page 32
LEFT
Waiyde, 1988
Colored pencil and graphite on paper
15⅜ × 17 inches

RIGHT
Traci, 1988
Colored pencil on paper
15 × 14¼ inches

Page 34
LEFT
Mohawk, c. 1988
Colored pencil and graphite on tracing paper
20¼ × 14½ inches

RIGHT
Esther, 1988
Colored pencil, graphite, and collage on paper
19¾ × 18⅛ inches

Page 35
Billy, 1988
Watercolor, graphite, colored pencil, and fluorescent acrylic on paper
19⅜ × 19¼ inches

Page 36
Monica, 1990
Graphite and colored pencil on paper
11 × 9½ inches

Page 63
ABOVE
S.F. Bay Boats, c. 1987
Graphite and colored pencil on paper
14 × 17 inches

BELOW
San Francisco and Boats, c. 1987
Graphite and colored pencil on paper
14½ × 17 inches

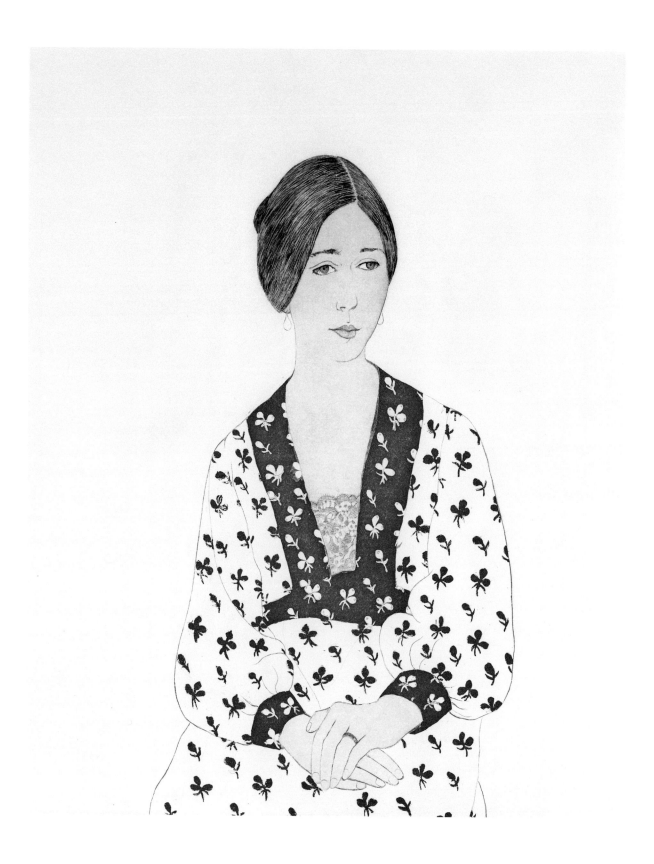

Biography

BORN

1926 Boise, Idaho

EDUCATION

1944–48 Stanford University, Stanford, CA. B.A. 1948
1945 Escuela de Pintura y Escultura de la Escuela Esmeralda,
 Secretaría de Educación Pública, Mexico, DF
1946–47 California School of Fine Arts, San Francisco
1948 Ecole des Beaux Arts de Fontainbleau, France
1948–50 Academie Julian, Paris
 Academie de la Grand Chaumiere, Paris
1951–52 California School of Fine Arts, San Francisco
1955 St. Cére/Aubusson, France
1957–58 San Francisco State College, San Francisco, CA

HONORS AND AWARDS

1951 California State Fair, Sacramento. Purchase Award
1956 San Francisco Women Artists. Memorial Fund Prize
 in Graphic Arts
1957 San Francisco Arts Festival. Honorable Mention
 San Francisco Women Artists. Honorable Mention,
 Painting and Graphic
1958 California Society of Etchers, San Francisco. Honorable
 Mention
1959 San Francisco Women Artists. Graphic Award:
 Vera Adams Davis Memorial Prize

 San Francisco Arts Festival. Honorable Mention
 California Society of Etchers, San Francisco. Honorable
 Mention
1960 San Francisco Women Artists. Honorable Mention,
 Painting and Graphic
1961 San Francisco Arts Festival. Purchase Award
 San Francisco Art Institute. Anne Brewer Memorial
 Prize Fund Purchase
 California Society of Etchers, San Francisco. Purchase
 Award
1962 San Francisco Women Artists. Honorable Mention
1964 Pasadena Museum of Modern Art, Pasadena, CA.
 Purchase Award
1965 California Society of Etchers, San Francisco. Purchase
 Award
1968 Richmond Museum, Richmond, CA. Purchase Award
1970 San Francisco Women Artists. Graphic Arts Award
1971 Honolulu Academy of the Arts, *Hawaii National Print
 Exhibition*. Purchase Award
1974 The Oakland Museum, Oakland, CA. Purchase Award
1975 The Oakland Museum, *Prints: California*. Purchase Award
 California Society of Printmakers, San Francisco.
 Purchase Award
1978 Hayward Festival of the Arts Invitational, Hayward, CA.
 Purchase Award
1980 Honolulu Academy of the Arts, *Hawaii National Print
 Exhibition*. Purchase Award

1981 San Francisco Arts Commission. Award of Honor in Graphics

1993 California Society of Printmakers, San Francisco. First Annual Distinguished Artist Award

Solo Exhibitions

1952 Lucien Labaudt Art Gallery, San Francisco, *Beth Van Hoesen,* March 26–April 5

1959 M. H. de Young Memorial Museum, San Francisco, *Exhibition of Drypoints and Etchings by Beth Van Hoesen,* February 19–March 22

1960 David Cole Gallery, Sausalito, CA, *Etchings, Dry Point & Engravings by Beth Van Hoesen,* November 4–26

1961 Achenbach Foundation for Graphic Arts, California Palace of the Legion of Honor, San Francisco, *Beth Van Hoesen,* November 4–December 3. Travel to Boise Gallery of Art, Boise, ID, October 3–28; Santa Barbara Museum of Art, Santa Barbara, CA; IBM Corporation, San Jose, CA. Catalogue

1965 Peninsula Gallery, Menlo Park, CA, *Prints by Beth Van Hoesen,* November 2–27

Plunkett Gallery, Des Moines, IA, *Beth Van Hoesen*

Fountain Gallery, Portland, OR, *Prints by Beth Van Hoesen*

Santa Barbara Museum of Art, Santa Barbara, CA, *Beth Van Hoesen*

1966 Felix Landau Gallery, Los Angeles, *Beth Van Hoesen*

Hansen Gallery, San Francisco, *Beth Van Hoesen: Intaglio Prints,* November 18–December 8

E.B. Crocker Art Gallery, Sacramento, CA, *Beth Van Hoesen*

1967 San Diego State University, San Diego, CA, *The Eloquence of the Line: Prints by Beth Van Hoesen*

Fountain Gallery, Portland, *Favorite Prints by Beth Van Hoesen*

1969 Civic Arts Print Gallery, Walnut Creek, CA, *Beth Van Hoesen—Etching,* August 26–September 17

1970 Fountain Gallery, Portland, *Favorite Prints by Beth Van Hoesen,* April 9–30

1971 John Bolles Gallery, San Francisco, *"The Nude Man," Beth Van Hoesen,* May 25–June 18

Smith Andersen Gallery, Palo Alto, CA, *Beth Van Hoesen,* December 10, 1971–January 7, 1972

Mt. Angel Abbey, OR, *Beth Van Hoesen*

1972 Rio Hondo College, Whittier, CA, *Beth Van Hoesen*

1973 University of Idaho, Moscow, *Beth Van Hoesen*

Jewett Exhibition Center, College of Idaho, Caldwell, ID, *Beth Van Hoesen*

Fountain Gallery, Portland, *Handcolored Etchings by Beth Van Hoesen,* July

1974 Contemporary Graphics Center of the Santa Barbara Museum of Art, Santa Barbara, CA, *Beth Van Hoesen: Poppies and Peony*

Achenbach Foundation for Graphic Arts, California Palace of the Legion of Honor, San Francisco, *Beth Van Hoesen: Color Intaglio Prints,* January 19–March 17. Catalogue

Smith Andersen Gallery, Palo Alto, CA, *Beth Van Hoesen: Intaglio Prints,* February–March

Linda Farris Gallery, Seattle, *Beth Van Hoesen: Intaglio Prints,* February–March

Gallery West, Seattle, *Beth Van Hoesen*

1975 Sun Gallery, Hayward Area Festival of the Arts, Hayward, CA, *Beth Van Hoesen: Intaglios,* July 19–August 30

1976 Contemporary Graphics Center of the Santa Barbara Museum of Art, Santa Barbara, CA, *Beth Van Hoesen: Poppies,* May 28–June 30

1977 Hansen Fuller Gallery, San Francisco, *Beth Van Hoesen*

1979 Young Gallery, San Jose, CA, *Beth Van Hoesen*

1980 The Oakland Museum, Oakland, CA, *Beth Van Hoesen– Prints, Drawings, Watercolors,* May 13–July 6. Catalogue

Hansen Fuller Goldeen Gallery, San Francisco, *Beth Van Hoesen,* May 29–June 21

1981 India Ink Gallery, Santa Monica, CA, *Beth Van Hoesen: Prints and Drawings*

Young Gallery, San Jose, CA, *Beth Van Hoesen*

Hill Gallery, El Paso, TX, *Beth Van Hoesen*

1982 John Berggruen Gallery, San Francisco, *Beth Van Hoesen.* Catalogue

Stanford University Art Gallery, Stanford, CA, *Beth Van Hoesen*

1983 Art Museum Association Traveling Exhibition, *Beth Van Hoesen: Prints, Drawings, Paintings.* Travel to De Saisset Museum, University of Santa Clara, Santa Clara, CA, January 11–March 13, 1983; El Paso Art Museum, El Paso, TX; Fresno Arts Center and Museum, Fresno, CA; Kaiser Center, Oakland, CA; North Dakota State University, Fargo; The Haggin Museum, Stockton, CA; Scottsdale Center for the Arts, Scottsdale, AZ;

Boehm Art Gallery, Palomar College, San Marcos, CA; Kittredge Gallery, University of Puget Sound, Tacoma, WA, January 27–February 22, 1985; Missouri Botanical Garden, St. Louis, April 19–June 2, 1985. Catalogue

Young Gallery, San Jose, CA, *Beth Van Hoesen: Prints and Drawings,* January 24–March 11

Stanford University Art Gallery, *Beth Van Hoesen: Prints and Drawings,* October 4–December 4

John Berggruen Gallery, San Francisco, *Beth Van Hoesen: Newborn Suites*

Fountain Gallery, Portland, *Prints by Beth Van Hoesen,* December 10, 1983– January 7, 1984

1984 Arizona State University Art Collections, Tempe, *Wonderful Animals of Beth Van Hoesen*

1985 John Berggruen Gallery, San Francisco, *Beth Van Hoesen,* September 5–October 5

1986 Young Gallery, San Jose, CA

1987 Palo Alto Cultural Center, Palo Alto, CA, *Selections from Beth Van Hoesen: Creatures,* December 1987–February 14, 1988

John Berggruen Gallery, San Francisco, *Beth Van Hoesen*

1988 Himovitz-Jenson Gallery, Sacramento, CA, *Beth Van Hoesen: Contemporary Realist,* March 1–April 2

The Nature Company Store and Gallery, Concord, MA, *Beth Van Hoesen: Creatures,* April 10–May 22

Jane Haslem Salon, Washington, DC, *Beth Van Hoesen: Creatures, Flowers and Figures—Prints, Drawings and Watercolors 1961–1988,* June–July

John Berggruen Gallery, San Francisco, *Beth Van Hoesen: Recent Prints, Drawings and Watercolors,* September 8–October 8

1990 Barbara Linhard Gallery/First Impressions, Carmel, CA, *Beth Van Hoesen: Prints and Drawings,* September 8–30

1991 Himovitz-Miller Gallery, Sacramento, CA, *Beth Van Hoesen: Creatures and Dolls,* November–December

Faculty Club, Institute for Research on Women and Gender, Stanford University, Stanford, CA

John Berggruen Gallery, San Francisco, *Beth Van Hoesen: Recent Works on Paper,* December 5, 1991–January 4, 1992

1992 Young Gallery, Los Gatos, CA, *Beth Van Hoesen: New and Revisited Works on Paper,* June 30–August 14

1993 Northpoint Gallery, San Francisco, *Beth Van Hoesen: Intaglio Prints*

2001 Dominician University of California, San Rafael, CA, *Drawings: Works by Beth Van Hoesen,* February 2–March 31

2006 Richard L. Nelson Gallery, University of California, Davis, *From the Permanent Collection: Beth Van Hoesen,* March 30–May 21

The Sequoias, San Francisco, *Beth Van Hoesen,* June 26–August 10

2009 Portland Art Museum, OR, *Sensitive Vision: The Prints of Beth Van Hoesen,* May 2–August 16. Brochure

Fresno Art Museum, Fresno, CA, *Beth Van Hoesen: The Observant Eye,* November 20, 2009–February 2, 2010. Travel to Christian Petersen Art Museum, Iowa State University, Ames, March 9–August 6, 2010. Catalogue

Two-Artist Exhibitions

1954 Gump's Gallery, San Francisco, *Beth Van Hoesen—Drawings/Mark Adams—Tapestries,* October 28–November 11

1957 Stanford University Art Gallery, Stanford, CA, *Contemporary Tapestries by Mark Adams; Dry Point Prints by Beth Van Hoesen,* December 17, 1957–January 5, 1958

1969 Monterey Peninsula Museum of Art, Monterey, CA, *Tapestries by Mark Adams and Graphics by Beth Van Hoesen*

1973 Temple Emanu-El, San Francisco, *Beth Van Hoesen: Intaglio Prints; Mark Adams: Drawings, Paintings, Tapestries,* July 27–October 15

1985 University of Tennessee, Chattanooga, *Two California Artists: Mark Adams and Beth Van Hoesen: Prints, Drawings, Watercolors,* September 9–27. Travel to La Grange College, La Grange, GA, October

1988 Cunningham Art Gallery, *Beth Van Hoesen and Mark Adams,* December

1995 John Berggruen Gallery, San Francisco, *Mark Adams, A Way with Color; Beth Van Hoesen, Works on Paper,* November 7–December 2

Hunterdon County Art Center, Clinton, NJ, *Third Annual Print Exhibit*, March 15–April 30. Travel to Richmond Art Center, Richmond, CA. Brochure

Bradley Print Exhibition, IL, *The Artist Looks At Us.* Traveled by the San Francisco Art Institute Art Bank, San Francisco, CA

California State Fair and Exposition, Sacramento, *Art.* Catalogue

Honolulu Academy of the Arts, Honolulu, HI, *Three Intaglio Printmakers: Beth Van Hoesen, Karl Kasten, Gordon Cook.* Travel to San Francisco Museum of Art, August 20–September 20

San Francisco Museum of Art, *Prints by Bay Area Artists, No. 2*, August 20–September 27

San Francisco Arts Festival, *XIIth San Francisco Arts Festival*, September 25–28. Catalogue

The Oakland Museum, Oakland, CA, and California Palace of the Legion of Honor, San Francisco, *Bay Printmakers Society Fourth National Exhibition.* Catalogue

Honolulu Academy of the Arts, *Thirty-First Annual Exhibition and 50th State National Exhibition,* November 5–December 6

Museum of Fine Arts, Boston, *Boston Printmakers 12th Annual Print Exhibition,* November 10–December 6. Catalogue

San Francisco Museum of Art, *San Francisco Women Artists' 34th Annual Exhibition,* November 14–December 6. Catalogue

M. H. de Young Memorial Museum, San Francisco, *Painting and Sculpture in the San Francisco Art Association, 1959–1960,* December. Catalogue

1960 Achenbach Foundation for Graphic Arts, Palace of the Legion of Honor, San Francisco, *Winter Invitational*

San Francisco Museum of Art, *San Francisco Art Association 24th Annual Exhibition*

Richmond Art Center, Richmond, CA, *Richmond Annual Print Exhibition*

California Palace of the Legion of Honor, San Francisco, *14th Annual San Francisco Arts Festival*

Pennsylvania Academy of the Fine Arts, Philadelphia

California State Fair and Exposition, Sacramento, *Art.* Catalogue

California Palace of the Legion of Honor, San Francisco, *California Society of Etchers National Annual Exhibition*

San Francisco Museum of Art, *California Society of Etchers 1960 Members' Exhibition*, August 25–September 25

San Francisco Arts Festival, *14th Annual San Francisco Arts Festival*, September 15–18

San Francisco Museum of Art, *San Francisco Women Artists' 35th Annual Exhibition*, October 28–December 4. Catalogue

Museum of Fine Arts, Boston, *Boston Printmakers 13th Annual Print Exhibition,* November 1–30. Catalogue

San Francisco Museum of Art, *San Francisco Art Institute 24th Annual Exhibition*

1961 Pennsylvania Academy of the Fine Arts, Philadelphia

The Oakland Museum, *Bay Printmakers Society Sixth National Exhibition.* Catalogue

San Francisco Museum of Art, *California Society of Etchers National Annual Exhibition*

Achenbach Foundation for Graphic Arts, California Palace of the Legion of Honor, San Francisco, *First Annual Printmakers Exhibition Invitational.* Travel to Gallery House, Menlo Park, CA, December 6–31; Foothill College, Los Altos Hills, CA; Scripps College Claremont, CA. Brochure

San Francisco Museum of Art, *Flower Show*

California State Fair and Exposition, Sacramento, *Art.* Catalogue

San Francisco Arts Festival, *The San Francisco Art Institute,* September 21–24. Brochure

San Francisco Museum of Art, *25th Annual Drawing, Print, and Sculpture Exhibition of the San Francisco Art Institute,* October 21–November 19. Catalogue

University of Kentucky, Lexington, *Graphics '61,* November 19–December. Catalogue

San Francisco Museum of Art, *San Francisco Women Artists' 36th Annual Exhibition,* December 1–31. Catalogue

Achenbach Foundation for Graphic Arts, California Palace of the Legion of Honor, San Francisco, *California Society of Printmakers Annual Exhibition*

Achenbach Foundation for Graphic Arts, California Palace of the Legion of Honor, San Francisco, *15th Annual San Francisco Arts Festival*

1962 Hansen Gallery, San Francisco, *Methods of Printmaking,* January 17–February 5

Seattle Art Museum, *Northwest Printmakers 32nd International Exhibition,* February 7–March 4. Travel to Portland Art Museum, OR, March 9–28. Brochure

Brooklyn Museum, Brooklyn, NY, *13th National Print Exhibition,* March 6–June 3. Travel through 1964 by the American Federation of the Arts to Kalamazoo Institute of Arts, Kalamazoo, MI; Peterson State College, Wayne, NJ; University of Pennsylvania, Philadelphia; University of Wichita, KS; Kent State College, Kent, OH; De Cordova and Dana Museum, Lincoln, MA; Montclair Art Museum, Montclair, NJ; Morgan State College, Baltimore, MD; National Gallery of Canada Exhibition Extension Services, Ottawa; San Francisco State College, San Francisco, CA. Catalogue

Eric Locke Gallery, San Francisco, *Prints: The Californians 1962,* April 10–May 19

San Francisco Museum of Art, *81st Annual Painting Exhibition of the San Francisco Art Institute,* April 20–May 20. Catalogue

San Francisco Museum of Art, *Arts of San Francisco*

David Cole Gallery, San Francisco, *Representative Works,* September 13–October 13

San Francisco Arts Festival, *16th Annual San Francisco Arts Festival,* September 20–24. Brochure

Achenbach Foundation for Graphic Arts, California Palace of the Legion of Honor, San Francisco, *Six Printmakers of the Bay Area.* Travel. Catalogue

Museum of Fine Arts, Boston, *Boston Printmakers 15th Annual Print Exhibition,* October 30–December 2. Catalogue

San Francisco Museum of Art, *San Francisco Women Artists' 37th Annual Exhibition,* December 1–30. Catalogue

1963 Pennsylvania Academy of the Fine Arts, Philadelphia, *158th Annual Exhibition—Watercolors, Prints, Drawings,* January 18–March 3. Catalogue

Seattle Art Museum, *Northwest Printmakers 33rd International Exhibition.* Travel to Portland Art Museum, OR

Hansen Gallery, San Francisco, *Methods of Printmaking*

Richmond Art Center, Richmond, CA, *Print-Sculpture Annual,* September 22–October 20. Brochure

M. H. de Young Memorial Museum, San Francisco, *New Images of San Francisco,* December 17, 1963–January 19, 1964

American Federation of Arts Traveling Exhibition, *Some Images of Women*

1964 I.B.M., San Jose, CA. Travel to C. Troup Gallery, Dallas, TX

Achenbach Foundation for Graphic Arts, California Palace of the Legion of Honor, San Francisco, *Original Prints, 1964: California Society of Etchers 50th Anniversary Exhibition,* April 4–May 10. Catalogue

Pratt Graphic Art Center, New York, NY, *1st International Miniature Print Exhibition,* April 7–30

Pasadena Art Museum, Pasadena, CA, *Fourth Biennial Print Exhibition,* October 6–November 6. Catalogue

San Francisco Museum of Art, *San Francisco Women Artists' 39th Annual Exhibition,* November 13–December 13. Catalogue

M. H. de Young Memorial Museum, San Francisco

San Francisco Art Institute, *California Printmakers.* Travel. Catalogue

1965 Norfolk Museum of Arts & Sciences, Norfolk, VA, *XXIst American Drawing Biennial,* January 4–31. Catalogue

Pennsylvania Academy of the Fine Arts, Philadelphia, *160th Annual Exhibition—Watercolors, Prints, Drawings,* January 22–March 7. Catalogue

California Palace of the Legion of Honor, San Francisco, *1965 Fine Arts Auction of the San Francisco Art Institute,* February 11–24. Brochure

San Francisco Museum of Art, *Beth Van Hoesen, Dennis Beall, Jeryl Parker: Prints & Drawings,* March 9–April 11

Laguna Beach Art Association, Laguna Beach, CA, *The Figure: West Coast,* March

San Francisco Art Institute, *California Society of Etchers 1965 Members' Exhibition,* April 7–May 2

San Francisco Museum of Art, *California Society of Etchers National Print Exhibition,* June 30–August 1. Award. Brochure

Achenbach Foundation for Graphic Arts, California Palace of the Legion of Honor, San Francisco, *California Society of Etchers Annual Exhibition.* Award

Sponsored by The Brooklyn Museum, *Amerikanische Radierungen.* Travel throughout Germany. Catalogue

San Francisco Museum of Art, *San Francisco Women Artists 40th Annual Exhibition,* November 13–December 12. Catalogue

1966　Brooklyn Museum, Brooklyn, NY, *15th National Print Exhibition,* January 31–May 29. Catalogue

Oakland Art Museum Kaiser Gallery, Oakland, CA, *Contemporary Prints from Northern California,* March 5–25. Travel to I.B.M. Gallery, New York, NY, April 5–23; C. Troup Gallery, Dallas, TX. Catalogue

C. Troup Gallery, Dallas, *Bay Area Printmakers: John Ihle, Beth Van Hoesen, Dennis Beall,* April 24–May

Achenbach Foundation for Graphic Arts, California Palace of the Legion of Honor, San Francisco, *California Society of Etchers Annual Exhibition.* Travel to E. B. Crocker Art Gallery, Sacramento, CA

1967　California Palace of the Legion of Honor, San Francisco, *1967 Fine Arts Auction of the San Francisco Art Institute,* January 26–February 2. Catalogue

Fine Arts Gallery of San Diego, San Diego, CA, *1967 San Diego Art Guild Graphic Exhibition,* March 18–April 23. Brochure

The Print Club of Albany, Albany Institute of History and Art, Albany, NY, *First Biennial Small Print Exhibition,* April 2–30. Catalogue

Otis Art Institute, Los Angeles

Cathedral House at Grace Cathedral, San Francisco, *Church Art Today,* December 1–22. Brochure

1968　Brooklyn Museum, Brooklyn, NY, *16th National Print Exhibition: 2 Decades of American Prints 1947–1968,* October 29, 1968–January 26, 1969. Catalogue

The Oakland Museum, *Contemporary Prints from Northern California*

1969　Lobby Gallery, Illinois Bell Telephone Company, Chicago, *California Printmakers,* March 3–April 4. Brochure

San Francisco Museum of Art, *National 1970 Drawing Exhibition,* December 17, 1969–January 25, 1970. Catalogue

1970　The 1970 World Exposition, Osaka, Japan, *The Kathiren Poulos Collection, Contemporary American Graphics,* March 31–April 5. Travel to Tokyo, April 14–19. Brochure

San Francisco Museum of Art, *San Francisco Women Artists' 43rd Annual Exhibition,* June 17–July 19. Brochure

C. Troup Gallery, Dallas, *Fall 1970 Salute: 3 Creative Women Artists,* September 20–October 17

Honolulu Academy of the Arts, Honolulu, HI

Norfolk Museum of Arts & Sciences, Norfolk, VA

University of Kentucky Art Gallery, Lexington, *Graphics '71, West Coast U.S.A.,* November 29–December 20. Traveled by the Smithsonian Institution Traveling Exhibitions Service, Washington, DC, to Paducah Art Gallery, Paducah, KY, January–February 1971. Catalogue

1971　Honolulu Academy of the Arts, *1st Hawaii National Print Exhibition,* February 4–March 7. Award. Catalogue

Fine Arts Gallery of San Diego, San Diego, CA, *Second National Invitational Print Show,* October 2–31. Brochure

56th National Orange Show, San Bernardino, CA, *All California Art Exhibition*

University of Kentucky, *Graphics West Coast*

1972　Capricorn Asunder Gallery, San Francisco, *San Francisco Women Artists 1972: Painting, Sculpture, Graphics,* January 15–February 19. Brochure

Walnut Creek Civic Arts Gallery, Walnut Creek, CA, *For the Birds*

San Francisco Art Institute, *Crown Point Press,* September 1–October 1. Catalogue

1973　The Oakland Museum, *Life Drawings and Studio Set-ups,* March

Honolulu Academy of the Arts, *2nd Hawaii National Print Exhibition,* April 27–May 27. Catalogue

1974　Van Straaten Gallery, Chicago, *California in Print*

The Oakland Museum. Award

1975　Honolulu Academy of the Arts, *3rd Hawaii National Print Exhibition*

Madison Art Center, Madison, WI, *New American Graphics,* March 14–April 8, 1975. Catalogue

The Oakland Museum, *Prints California,* April 29–July 6. Travel to Contemporary Graphics Center of the Santa Barbara Museum of Art, Santa Barbara, CA, August 1–September 2. Award. Catalogue

1976　Achenbach Foundation for Graphic Arts, California Palace of the Legion of Honor, San Francisco, *Artists' Portraits.* Travel to Sacred Heart Schools, Menlo Park, CA

1977　Smith Andersen Gallery, Palo Alto, CA, *Mark Adams, Gordon Cook, Beth Van Hoesen—Work on Paper,* April 29–June 8

Impressions Gallery, Boston, *West Coast Prints*

Brooklyn Museum, Brooklyn, NY, *Thirty Years of American Printmaking*

Achenbach Foundation for Graphic Arts, California Palace of the Legion of Honor, San Francisco, *Recent Acquisitions at the Achenbach Foundation*

Fine Arts Gallery of San Diego, San Diego, CA, *Invitational American Drawing Exhibition,* September 17–October 30. Catalogue

1978 Mills College Art Gallery, Oakland, CA, *California Society of Printmakers & Los Angeles Society of Printmakers*

New Gallery of Contemporary Art, Cleveland, OH

University of North Dakota, Grand Forks

Achenbach Foundation for Graphic Arts, California Palace of the Legion of Honor, San Francisco, *Artists' Portraits of Artists*

Walnut Creek Civic Arts Center, Walnut Creek, CA, *Fine Art Presses*

California State Capitol Building, Sacramento, *A Summer Exhibition—Selected Works from the California State Fair Collection*

1979 Achenbach Foundation for Graphic Arts, California Palace of the Legion of Honor, San Francisco

1980 Allport Associates Gallery, Larkspur, CA, *Prints and Monoprints,* January 9–February 2

Pratt Manhattan Center Gallery, New York, NY, *Prints from Northern California*

University of Massachusetts, Amherst, *Prints from Northern California*

Honolulu Academy of the Arts, *8th Hawaii National Print Exhibition.* Award

Allport Associates Gallery, Larkspur, CA, *Flowers: Prints and Monotypes,* April 13–May 15

1981 Tahir Gallery, New Orleans, LA, *American Self-Portraits*

Achenbach Foundation for Graphic Arts, California Palace of the Legion of Honor, San Francisco, *Animals Real and Imagined*

Capricorn Asunder Gallery, San Francisco, *San Francisco Art Commission Award of Honor Exhibition*

1982 John Berggruen Gallery, San Francisco

1983 Charles Campbell Gallery, San Francisco, *Figure Drawings: Five San Francisco Artists,* January 5–February 12. Catalogue

Port of History Museum, Philadelphia, PA, *Printed by Women,* February 17–March 27

Glastonbury Gallery, San Francisco, *A Selection of Contemporary Drawings,* February 17–March 31

The Print Club, Philadelphia, *Choice Prints: Recent Works by Various Artists,* September 6–October 8

Corpus Christi State University, Corpus Christi, TX, *Creatures in Print,* September 8–October 20. Travel through 1984

De Saisset Museum, University of Santa Clara, Santa Clara, CA, *Bon a Tirer—Fine Arts Presses of the Bay Area,* September 27–December 11

Tahir Gallery, New Orleans, *American Women Artists,* October 14–November 5

Susan Blanchard Gallery, New York, NY

Mills College Art Gallery, Oakland, CA

Modernism Gallery, San Francisco, *California Drawings,* December 16, 1983–January 28, 1984

1984 Marin County Civic Center, San Rafael, CA, *California Society of Printmakers,* January 9–February 2

David Cole Gallery, Inverness, CA, *A Personal Selection/Collection,* April 8–May 27

World Print Council, *Prints U.S.A.* Traveling Exhibition, 1984–86. Catalogue

Allport Associates Gallery, San Francisco, *Recent Bay Area Prints,* June 20–July 7

Orr's Gallery, San Diego, *Contemporary American Realists,* November 19, 1984–January 19, 1985

1985 TransAmerica Pyramid, San Francisco, *A City Collects,* February 25–March 29

Glastonbury Gallery, San Francisco, *The Small Press Phenomenon: Work from Eighteen Bay Area Fine Art Presses,* March 19–April 18

The Oakland Museum, *Art in the San Francisco Bay Area, 1945–1980,* June 15–August 18. Catalogue

Euphrat Gallery, De Anza College, Cupertino, CA, *Art Collectors In and Around Silicon Valley, 1985.* Catalogue

Portland Art Museum, OR

San Francisco Museum of Modern Art, *Moses Lasky Collection,* October

William Sawyer Gallery, San Francisco, *American Realism: Seventy-five Contemporary Artists,* November 5–December 21

San Francisco Museum of Modern Art, *American Realism: Twentieth Century Drawings and Watercolors,* November 7, 1985–January 12, 1986. Travel to Boise Art Museum. Catalogue

Tahir Gallery, New Orleans

1986 Charles Campbell Gallery, San Francisco, *Life Drawing–1980s: Seven San Francisco Artists,* January 7–February 1. Catalogue

Fountain Gallery, Portland, *25th Anniversary Exhibition,* June 5–28. Catalogue

Fresno Arts Center and Museum, Fresno, CA, *From the Collection,* September 2, 1986–August 2, 1987

Fresno Arts Center and Museum, *In the Advent of Change, 1945–1969,* October 10–December 28

1987 Oakland Museum of Art, Oakes Gallery, Oakland, CA, *Cream of California Prints,* May 8–September 27. Brochure

1988 Steven Wirtz Gallery, San Francisco, *Flo Allen: A Model for a Generation,* August 18–September 5

Santa Rosa Junior College Art Gallery, Santa Rosa, CA, *National Drawing Exhibition*

C. N. Gorman Museum, University of California, Davis, *The Tracks of Human-Animal Relationships,* April 22–May 13. Brochure

Jane Haslem Salon, Washington, DC, *Consonance.* Catalogue

John Berggruen Gallery, San Francisco, *Works on Paper,* September 8–October 8

1989 Arizona State University, Tempe, *Sixty Years of American Printmaking: 1930 to the Present,* April 2–August 20. Catalogue

Galerija Doma Kulture, Sarajevo, Bosnia, *Novija Americka Grafika,* April

Olympia & York/OM&M Associates, Los Angeles, *Mermaids and Creatures of the Sea,* May 15–August 17. Brochure

Hurlbutt Gallery, Greenwich Library, Greenwich, CT, *Bless the Creatures,* December 7, 1989–January 18, 1990

1990 New Orleans Museum of Art, *With Nothing On,* February 10–March 25. Catalogue

M. H. de Young Memorial Museum, San Francisco, *Bouquets to Art,* March 13–16

Oliver Art Center, California College of Arts & Crafts, Oakland, *Contemporary Realist Painting: Perception and Experience,* May 30–July 21

1991 John Berggruen Gallery, San Francisco, *Small Format Works on Paper,* June 26–August 3

Jane Haslem Salon, Washington, DC, *American Self-Portraits in Prints*

1992 I. Wolk Gallery, St. Helena, CA, *Works from the John Berggruen Gallery,* June 27–July 24

Palo Alto Cultural Center, Palo Alto, CA, *Directions in Bay Area Printmaking: 3 Decades,* September 20, 1992–January 3, 1993. Catalogue

Ewing Gallery of Art and Architecture, University of Tennessee, Knoxville, *The Intimate Collaboration: Prints from Teaberry Press.* Travel. Catalogue

John Berggruen Gallery, San Francisco, *Objects of Affection: Paintings, Sculpture, Works on Paper,* December 8, 1992–January 2, 1993

1993 Edith Caldwell Gallery, San Francisco, *Artists' Self-Portraits in Black & White,* May 3–29

Charles A. Wustum Museum of Fine Arts, Racine, WI, *Pets: Artists and An American Obsession,* June 13–September 5. Brochure

1994 Butterfield & Butterfield, San Francisco, CA, *Kala Art Institute's 20th Anniversary Celebration,* July 16

1995 John Berggruen Gallery, San Francisco, *Objects of Desire*

1998 John Berggruen Gallery, San Francisco, *Wild Things: Artists' Views of the Animal World*

Art Gallery, Yosemite Community College District, Yosemite, CA, August 27–September 25

Art Gallery, Modesto Junior College, Modesto, CA, *Related: An Exhibition of Artist Couples,* August 27–September 25

1999 Mendocino Art Center, Mendocino, CA, *Prints from made in California,* February

2004 b. sakata garo, Sacramento, CA, *Made in California Intaglio Editions: 24 Years of Prints,* February–April 3

2005 Arizona State University Art Museum, Tempe, *Fur, Feathers and Family: Our Relationship with Animals,* May 14–August 6

2007 Art Gallery, San Francisco State University, San Francisco, CA, *Pacific Light: California Watercolor Refracted, 1907–2007,* September 22–October 20

2008 Arizona State University Art Museum, Tempe, *Exploring Dreams: Images from the Permanent Collection,* May 17–September 28

Bibliography

BOOKS

Albright, Thomas. *Art in the San Francisco Bay Area, 1945–1980.* Berkeley: University of California Press, 1985.

Baker, Susan. "Naked Boys, Desiring Woman: Male Beauty in Modern Art and Photography" in *Hunks, Hotties and Pretty Boys: Twentieth-Century Representations of Male Beauty* (Steven L. Davis and Maglina Lubovich, eds.), pp. 22–26. Newcastle-upon-Tyne, UK: Cambridge Scholars Publishing, 2008. Illus.

Beard, James (Intro.), and Henry Hopkins (Foreword). *California Artists' Cookbook.* New York: Abbeville Press, 1982. Illus.

Connell, Evan (Foreword). *Beth Van Hoesen: Creatures, The Art of Seeing Animals.* A Yolla Bolly Press Book published by Chronicle Books, San Francisco, CA, 1987. French edition published by Flammarion, 1988.

Dimick, Carolyn Marie (Ed.), et al. *Voyages in English.* Chicago: Loyola University Press, 1988. Illus.

Drofnats Press. *Blushing Deep and Paling.* Stanford, CA: Drofnats Press, Stanford University, 1947. Illus.

Fisher, M. F. K. (Foreword). *California Fresh Cookbook.* Oakland, CA: The Junior League East Bay, 1985. Illus.

Mendelowitz, Daniel M. *A History of American Art.* New York: Holt, Rinehart and Winston, Inc., 1970. Illus. p. 481.

Van Hoesen, Beth. *A Collection of Wonderful Things: Intaglio Prints by Beth Van Hoesen.* San Francisco, CA: Scrimshaw Press, 1972.

Wisner, Penelope (Foreword). *Teddy Bears.* San Francisco: Fair Oaks Press, 2000.

CATALOGUES

Beeson, Connie. *Art Auction 1962.* Tiburon, CA: Belvedere-Tiburon Art Auction, 1962.

Black, Wendell H. *Oklahoma Printmakers Society First National Exhibition of Contemporary American Graphic Art.* Oklahoma City, OK: Oklahoma Printmakers Society, 1959.

Bookhart, D. Eric. *With Nothing On: Prints and Drawings of the Nude by American Artists.* New Orleans, LA: New Orleans Museum of Art, 1990. Illus.

Boston Printmakers. *12th Annual Print Exhibition.* Boston, MA: Boston Printmakers, 1959.

———. *13th Annual Print Exhibition.* Boston, MA: Boston Printmakers, 1960.

———. *15th Annual Print Exhibition.* Boston, MA: Boston Printmakers, 1962.

Bo-Tree Productions. *In Praise of Women Artists '77.* San Francisco, CA: Bo-Tree Productions, 1977. Illus.

Brown, Kathan. *Crown Point Press.* San Francisco, CA: San Francisco Art Institute, 1972. Illus.

Brown, Theophilus. *Life Drawing–1980s: Seven San Francisco Artists.* San Francisco: Charles Campbell Gallery, 1986.

California Society of Etchers. *Original Prints, 1964: California Society of Etchers 50th Anniversary Exhibition.* San Francisco, CA: California Society of Etchers, 1964.

California State Fair and Exposition. *Arts.* Sacramento, CA: California State Fair and Exposition, 1952.

———. *Arts*. Sacramento, CA: California State Fair and Exposition, 1958.

———. *Art*. Sacramento, CA: California State Fair and Exposition, 1961.

Charles A. Wustum Museum of Fine Arts. *Pets: Artists and An American Obsession*. Racine, WI: Charles A. Wustum Museum of Fine Arts, 1993.

Church Holland, Katherine. *The Art Collection: Federal Reserve Bank of San Francisco*. San Francisco, CA: Federal Reserve Bank, 1986. Illus.

Colescott, Warrington (Introduction). *New American Graphics*. Madison, WI: Madison Art Center, 1975.

Culler, George D. *22nd Annual Drawing and Print Exhibition of the San Francisco Art Association*. San Francisco, CA: San Francisco Museum of Art, 1958.

———. *25th Annual Drawing, Print, and Sculpture Exhibition of the San Francisco Art Institute*. San Francisco, CA: San Francisco Museum of Art, 1961.

———. *81st Annual Painting Exhibition of the San Francisco Art Institute*. San Francisco, CA: San Francisco Museum of Art, 1962.

Docter, Richard F. *Western Books 1973*. Los Angeles, CA: Rounce & Coffin Club, 1973.

Duggins, Grant. *Art*. Sacramento, CA: California State Fair and Exposition, 1959.

———. *Art*. Sacramento, CA: California State Fair and Exposition, 1960.

Foster, James W. *1st Hawaii National Print Exhibition*. Honolulu, HI: Honolulu Academy of Arts, 1971.

———. *2nd Hawaii National Print Exhibition*. Honolulu, HI: Honolulu Academy of Arts, 1973.

Fraser, Joseph T. *Catalogue of the 158th Annual Exhibition—Watercolors, Prints, Drawings*. Philadelphia: Pennsylvania Academy of the Fine Arts, 1963.

———. *Catalogue of the 160th Annual Exhibition—Watercolors, Prints, Drawings*. Philadelphia: Pennsylvania Academy of the Fine Arts, 1965.

Freeman, Richard B. *Graphics 61*. KY: University of Kentucky Art Department, 1961.

Gardiner, Henry G. *Invitational American Drawing Exhibition*. San Diego, CA: Fine Arts Gallery of San Diego, 1977.

Gedeon, Lucinda H., et al. *Sixty Years of American Printmaking: 1930 to the Present*. Tempe, AZ: Arizona State University, 1989.

Graf, Richard. *California Printmakers*. San Francisco, CA: San Francisco Art Institute, 1964. Illus.

Guenther, Bruce. *The Fountain Gallery of Art: 25th Anniversary Exhibition*. Portland, OR: Fountain Gallery of Art, 1986.

Hack, Teresa. *San Francisco Women Artists 43rd Annual Exhibition*. San Francisco, CA: San Francisco Women Artists, 1970.

Hamill, Tracy. *Beth Van Hoesen*. San Francisco: John Berggruen Gallery, 1982.

Heil, Walter, et al. *Painting and Sculpture in the San Francisco Art Association, 1959–1960*. San Francisco, CA: San Francisco Art Association, 1960. Illus.

Heyman, Therese Thau. *Beth Van Hoesen: Prints, Drawings, Watercolors*. Oakland, CA: The Oakland Museum Art Department, 1980. Illus.

Heyman, Therese Thau, et al. *Prints California*. Oakland, CA: The Oakland Museum, 1975. Illus.

Hopps, Walter. *Fourth Biennial Print Exhibition*. Pasadena, CA: Pasadena Art Museum, 1964.

Howe, Thomas Carr. *Painting and Sculpture in the San Francisco Art Association, 1958*. San Francisco, CA: San Francisco Art Association, 1958. Illus.

I.B.M. Gallery. *Contemporary Prints from Northern California*. New York: I.B.M. Gallery, 1966.

Jacobson, Cynthia, and Lindsay Laird. *The Rutgers Archives for Printmaking Studios: Catalogue of the Acquisitions, 1985–1987*. New Brunswik, NJ: Jane Voorhees Zimmerli Art Museum, Rutgers, The State University of New Jersey, 1988.

Jane Haslem Salon. *Consonance*. Washington, DC: Jane Haslem Salon, 1988.

Johnson, Robert Flynn. *Beth Van Hoesen*. San Francisco, CA: The Art Museum Association, 1983. Illus.

Johnson, Una E. *13th National Print Exhibition*. Brooklyn, NY: The Brooklyn Museum, 1962.

———. *Amerikanische Radierungen*. Bonn, Germany: Sponsored by The Brooklyn Museum, 1965.

———. *15th National Print Exhibition*. Brooklyn, NY: The Brooklyn Museum, 1966. Illus.

———. *16th National Print Exhibition: 2 Decades of American Prints 1947–1968*. Brooklyn, NY: The Brooklyn Museum, 1968.

Kastner, Fenton. *Graphics '71, West Coast U.S.A.* Lexington, KY: University of Kentucky Art Gallery, 1970. Illus.

———. *Beth Van Hoesen*. San Francisco: Achenbach Foundation for Graphic Arts, California Palace of the Legion of Honor, 1974.

Linhares, Phil. *Seven Touring Exhibitions 1968–69*. San Francisco, CA: San Francisco Art Institute, 1968. Illus.

Lorenz, Richard. *Beth Van Hoesen: Works on Paper.* San Francisco, CA: Chronicle Books and John Berggruen Gallery, 1995.

Martin, Alvin. *American Realism: Twentieth-Century Drawings and Watercolors From the Glenn C. Janss Collection.* New York: Harry N. Abrams, Inc.; San Francisco, CA: San Francisco Museum of Modern Art, 1985.

Mayfield, Signe. *Directions in Bay Area Printmaking: Three Decades.* Palo Alto, CA: Palo Alto Cultural Center, 1992.

McConnell, James E. *1951 Art Exhibition.* Sacramento, CA: California State Fair, 1951.

Mills, Paul. "Art, The People, and Public Art Festivals" in *XIIth San Francisco Arts Festival.* San Francisco, CA: San Francisco Arts Commission, 1959.

———. *Bay Printmakers Society Sixth National Exhibition.* Oakland, CA: Bay Printmakers Society, 1961.

Mills, Paul, Therese Heyman, and Dennis Beall. *Contemporary Prints from Northern California for the Art in Embassies Program 1966–1968.* Oakland, CA: The Oakland Museum, 1968. Illus.

Mongan, Agnes. *XXI American Drawing Biennial.* Norfolk, VA: Norfolk Museum of Arts and Sciences, 1965.

Morley, Grace L. McCann. *Annual Watercolor, Drawing and Print Exhibition of the San Francisco Art Association.* San Francisco, CA: San Francisco Art Association, 1957.

Mumford, L. Quincy. *Catalog of the 14th National Exhibition of Prints Made During the Current Year.* Washington, DC: Library of Congress, 1956.

———. *Catalog of the 15th National Exhibition of Prints Made During the Current Year.* Washington, DC: Library of Congress, 1957.

Nordland, Gerald. *National 1970 Drawing Exhibition.* San Francisco: San Francisco Museum of Art, 1969

Orr-Cahall, Christina. *The Art of California: Selected Works from the Collection of The Oakland Museum.* Oakland, CA: The Oakland Museum; San Francisco: Chronicle Books, 1984.

Pennsylvania Academy of the Fine Arts. *Catalogue of the 154th Annual Exhibition—Watercolors, Prints, and Drawings.* Philadelphia: Pennsylvania Academy of the Fine Arts, 1959.

Rindfleisch, Jan. *Art Collectors In and Around Silicon Valley.* Cupertino, CA: Euphrat Gallery, De Anza College, 1985.

San Francisco Art Association. *Painting and Sculpture: Catalogue of the Art Bank of the SFAA, 1959–1960.* San Francisco, CA: San Francisco Art Association, 1959. Illus.

San Francisco Art Institute. *A Catalog of the Art Bank 1962/63.* San Francisco, CA: San Francisco Art Institute, 1963. Illus.

———. *Art Bank 64/66.* San Francisco, CA: San Francisco Art Institute, 1966. Illus.

———. *1965 Fine Arts Auction of the San Francisco Art Institute at the California Palace of the Legion of Honor.* San Francisco, CA: San Francisco Art Institute, 1965.

———. *Ten Touring Exhibitions 1965/66.* San Francisco, CA: San Francisco Art Institute, 1965.

———. *1967 Fine Arts Auction of the San Francisco Art Institute at the California Palace of the Legion of Honor.* San Francisco, CA: San Francisco Art Institute, 1967.

San Francisco Museum of Art. *California Society of Etchers National Print Exhibition 1965.* San Francisco, CA: San Francisco Museum of Art, 1965.

San Francisco Museum of Modern Art. *American Realism: Twentieth Century Drawings and Watercolors.* San Francisco, CA: San Francisco Museum of Modern Art, 1986.

San Francisco Women Artists. *26th Annual Exhibition.* San Francisco, CA: San Francisco Women Artists, 1951.

———. *27th Annual Exhibition.* San Francisco, CA: San Francisco Women Artists, 1952.

———. *28th Annual Exhibition.* San Francisco, CA: San Francisco Women Artists, 1953.

———. *29th Annual Exhibition.* San Francisco, CA: San Francisco Women Artists, 1954.

———. *31st Annual Exhibition.* San Francisco, CA: San Francisco Women Artists, 1956.

———. *32nd Annual Exhibition.* San Francisco, CA: San Francisco Women Artists, 1957.

———. *33rd Annual Exhibition.* San Francisco, CA: San Francisco Women Artists, 1958.

———. *34th Annual Exhibition.* San Francisco, CA: San Francisco Women Artists, 1959.

———. *35th Annual Exhibition.* San Francisco, CA: San Francisco Women Artists, 1960.

———. *36th Annual Exhibition.* San Francisco, CA: San Francisco Women Artists, 1961.

———. *37th Annual Exhibition.* San Francisco, CA: San Francisco Women Artists, 1962.

———. *39th Annual Exhibition.* San Francisco, CA: San Francisco Women Artists, 1964.

———. *40th Annual Exhibition.* San Francisco, CA: San Francisco Women Artists, 1965.

Schafer, Alice Pauline. *First Biennial Small Print Exhibition.* Albany, NY: The Print Club of Albany, Albany Institute of History and Art, 1967.

Thiebaud, Wayne. *Figure Drawings: Five San Francisco Artists.* San Francisco: Charles Campbell Gallery, 1983.

Troche, E. Gunther. *Beth Van Hoesen.* San Francisco: Achenbach Foundation for Graphic Arts, California Palace of the Legion of Honor, 1961. Illus.

———. *Six Printmakers of the Bay Area.* San Francisco: Achenbach Foundation for Graphic Arts, California Palace of the Legion of Honor, 1962. Illus.

Troche, E. Gunther, and Karl Kasten. *Bay Printmakers Society Fourth National Exhibition.* Oakland, CA: Bay Printmakers Society, 1958.

World Print Council. *Prints U.S.A.* San Francisco, CA: World Print Council, 1984.

Yates, Sam; and Timothy Berry. *The Intimate Collaboration: Prints from Teaberry Press.* Knoxville, TN: Ewing Gallery of Art and Architecture, University of Tennessee, 1992.

Zellerbach, Harold L. *5th Annual Arts Festival.* San Francisco, CA: San Francisco Art Commission, 1951.

——— et al. *XIth Annual Arts Festival.* San Francisco, CA: San Francisco Art Commission, 1957.

BROCHURES

1970 World Exposition. *The Kathiren Poulos Collection, Contemporary American Graphics.* San Francisco, CA: Takashimaya, 1970.

Bartlett, Rev. C. Julian. *Church Art Today.* San Francisco, CA: Grace Cathedral, 1957.

Boise Art Museum. *American Realism: Twentieth Century Drawings and Water Colors.* Boise, ID: Boise Art Museum, 1986.

C. N. Gorman Museum. *Human-Animal Relationships as Depicted in Art.* Davis, CA: C. N. Gorman Museum, University of California, 1988.

Dixon, Annette. *Sensitive Vision: The Prints of Beth Van Hoesen.* Portland, OR: Portland Art Museum, 2009.

Fine Arts Gallery. *Second National Invitational Print Show.* San Diego, CA: Fine Arts Gallery, 1971.

Gallery House. *First Annual Printmakers' Exhibition Invitational.* Menlo Park, CA: Gallery House, 1961.

Glauber, Robert H. *California Printmakers.* Chicago: Illinois Bell Telephone Company, 1969.

Hayward Art Forum of the Arts. *The Arts and a Community . . . Growing Together.* Hayward, CA: Hayward Art Forum of the Arts. Illus.

Heyman, Therese Thau. *Cream of California Prints.* Oakland, CA: Oakland Museum Art Department, 1987.

Hunterdon County Art Center. *Third Annual Print Exhibit.* Clinton, NJ: Hunterdon County Art Center, 1959.

International Graphic Arts Society. *Prints 1961.* New York: International Graphic Arts Society, 1961.

———. *Prints 1963.* New York: International Graphic Arts Society, 1963.

———. *Prints 1965.* New York: International Graphic Arts Society, 1965.

North Point Gallery. *Beth Van Hoesen: Intaglio Prints 1955–1975.* San Francisco, CA: North Point Gallery, 1993.

Northwest Printmakers. *Northwest Printmakers 32nd International Exhibition.* Seattle, WA: Northwest Printmakers, 1962.

Olympia & York/OM&M Associates. *Mermaids and Creatures of the Sea.* Los Angeles: Olympia & York/OM&M Associates, 1989.

Philadelphia Sketch Club. *1957 Annual Exhibition of Etchings.* Philadelphia, PA: Philadelphia Sketch Club, 1957.

Richmond Art Center. *Print-Sculpture Annual.* Richmond, CA: Richmond Art Center, 1963.

San Diego Art Guild. *1967 San Diego Art Guild Graphic Exhibition.* San Diego, CA: San Diego Art Guild, 1967.

San Francisco Art Commission. *16th Annual Art Festival.* San Francisco, CA: San Francisco Art Commission, 1962.

———. *San Francisco Women Artists 1972: Painting, Sculpture, Graphics.* San Francisco, CA: San Francisco Art Commission, 1972.

San Francisco Art Institute. *The San Francisco Art Institute: An Exhibition at the 1961 San Francisco Arts Festival.* San Francisco, CA: San Francisco Art Institute, 1961.

Valley of the Moon Vintage Festival. *Arts and Crafts Exhibition Sponsored by the Lucien Labaudt Art Gallery.* Sonoma, CA: Valley of the Moon Vintage Festival, 1952.

SELECTED ARTICLES

Albright, Thomas. "Art." *San Francisco Chronicle,* Nov. 24, 1957.

———. "An Impressive Pair of Shows in Oakland." *San Francisco Chronicle,* Mar. 24, 1973, p. 38.

———. "Print Competition Display at Oakland." *San Francisco Chronicle,* May 11, 1975, This World section, pp. 29–30. Illus.

———. "Graphic Bite and Technical Finesse." *San Francisco Chronicle,* June 20, 1980, p. 71. Illus.

Baker, Kenneth. "Life Drawing Going Strong in the Bay Area." *San Francisco Chronicle,* Datebook section, Jan. 21, 1986.

Baker, Naomi. "Beth Van Hoesen Show Due: SDS to Exhibit Notable Graphics." *Evening Tribune* (San Diego, CA), Apr. 7, 1967, p. E-4. Illus.

———. "Graphic Arts Display is Lively." *Evening Tribune* (San Diego, CA), Mar. 24, 1967.

Bassing, Jennifer. "Legion shows animal art—Durer to Disney." *Times* (San Mateo, CA), 1981.

Beaudin, Victoria. "Artist Reveals Strength in Simplicity." *Scottsdale [AZ] Daily Progress,* June 29, 1984. Illus.

Bechtle, Robert. "Beth Van Hoesen—Having Her Way with Line." *The California Printmaker,* Spring 1993, Cover & pp. 3–4.

"Beth Van Hoesen." *El Dorado* (Butler Co., KS), Nov. 7, 1957.

"Beth Van Hoesen: A Fine Line." *The Museum of California* (Oakland, CA), vol. 3, no. 11, May 1980, pp. 6–7. Illus.

"Beth Van Hoesen: Newborns." *The Print Collector's Newsletter,* Jan.–Feb. 1984. Illus.

"Beth Van Hoesen: One-Woman Renaissance in Prints." *Esquire,* vol. 44, no. 2, Aug. 1955, pp. 78–79. Illus.

Bloomfield, A. J. "Art That's Feminine But Not Frilly." *News-Call Bulletin* (San Francisco, CA), Nov. 26, 1960.

Connor, Celeste. "Beth Van Hoesen: The Art of Beholding." *Women's Studies,* no. 22, 1992, pp. 83–98. Illus.

Contact 15 (The San Francisco Collection of New Writing, Art, and Ideas), vol. 4, no. 1, July 1963. Illus., Cover & pp. 10–20.

Cress, Stephanie. "Beth Van Hoesen: 1993 Distinguished Artist Award Recipient." *The California Printmaker,* Spring 1993, pp. 4–5.

Cross, Miriam Dungan. "Magical Touch Seen in Van Hoesen Prints." *Oakland Tribune,* Nov. 18, 1961. Illus.

Dalkey, Victoria. "From creature comforts to gritty imagery." *Sacramento Bee,* Mar. 13, 1988, pp. 13, 19. Illus.

———. "Etch a Sketch: Collection of prints makes laborious process look easy." *Sacramento Bee,* Mar. 14, 2004

DeShong, Andrew. "Van Hoesen—Aquatints." *Artweek* (San Jose, CA), vol. 5, no. 10, Mar. 9, 1974. Illus.

Dills, Keith. "Tom Holland and Beth Van Hoesen." *Artweek,* Oct. 8, 1977, p. 5. Illus.

"Directions in Bay Area Printmaking." *Journal of the Print World,* Fall 1992, p. 8.

Drewes, Caroline. "Flavorsome Life in a Firehouse." *S.F. Sunday Examiner & Chronicle,* Oct. 2, 1966. Illus.

Eberle, Jean. "A Review: Van Hoesen, a Quiet Artist." *Idaho Sunday Statesman,* Oct. 21, 1962.

"Etchings and Drypoints by Beth Van Hoesen." *Contact 3* (San Francisco, CA), 1969, pp. 145 ff. Illus.

"Everyday subjects take on new life in Gallery exhibit of [Van] Hoesen's work." *Campus Report* (Stanford University), Oct. 12, 1983. Illus.

"Ex-Boisean Enters Work at Art Gallery." *Idaho Sunday Statesman* (Boise), Oct. 7, 1962. Illus.

"Ex-Idahoan in the Arts." *Idaho Sunday Statesman* (Boise), Nov. 19, 1961. Illus.

Ferger, Kim. "Van Hoesen's graphics seek the essential." *West End Word* (St. Louis, MO), May 2, 1985, p. 25. Illus.

Frankenstein, Alfred. "Depicting a Dream World." *San Francisco Chronicle,* Mar. 8, 1959, Highlight section, p. 19.

———. "Five Artists Provide a Lively Show at the de Young." *San Francisco Chronicle,* Mar. 8, 1959, This World section, pp. 25–28. Illus.

———. "The Legion Show—Virtuoso of the Line." *San Francisco Chronicle,* Nov. 12, 1961, This World section, p. 22. Illus.

———. "Varied Show by Women Artists." *San Francisco Chronicle,* Jan. 11, 1964, p. 27.

———. "Beth Van Hoesen: Some Resourceful Etchings." *San Francisco Chronicle,* Nov. 23, 1966, p. 35. Illus.

———. "A Wonderful Collection." *San Francisco Chronicle,* Nov. 26, 1972, This World section, p. 42. Illus.

———. "Art: Van Hoesen Prints." *San Francisco Sunday Examiner & Chronicle,* Jan. 27, 1974, This World section.

Fremont Smith, Elliot. "Lines of Sight." *Saturday Review of the Arts,* vol. 1, no. 2, Feb. 3, 1973, p. 70. Illus.

Fried, Alexander. "Art." *San Francisco Examiner,* Nov. 7, 1954.

———. "Art." *San Francisco Examiner,* Nov. 18, 1956.

———. "A Visit with the Etchers." *San Francisco Examiner,* May 4, 1958, Pictorial Review section, p. 21. Illus.

———. "Art." *San Francisco Examiner,* Nov. 30, 1958.

———. "Art." *San Francisco Examiner,* Mar. 8, 1959, p. 19.

———. "Samples of Art for Gallery Visitors." *San Francisco Examiner,* Sept. 6, 1959, p. 14.

———. "A Score for the Distaff Side." *San Francisco Examiner,* Nov. 29, 1959.

———. "Drypoints and Oils on View." *San Francisco Examiner,* Nov. 12, 1961.

———. "It's a Good Year for the Women." *San Francisco Examiner,* Dec. 9, 1962.

———. "Prints and Pipes—They're Both Art." *San Francisco Examiner,* Dec. 9, 1966, p. 36. Illus.

———. "Print maker at her peak." *San Francisco Examiner,* Jan. 30, 1974, p. 24. Illus.

Genesis West, vol. 1, no. 1, Fall 1962. Illus. pp. 42, 52, 64.

Hicks, Bob. "Discovering the hidden sublime in the ordinary." *Oregonian* (Portland), May 8, 2009, pp. 21–22. Illus.

Hodel, Emilia. "At Home in Inner Space for Artists." *S.F. News Call-Bulletin* (San Francisco), Nov. 2, 1961.

Holt, Patricia. "'Creatures' Pays Loving Homage to Animals." *San Francisco Chronicle*, Dec. 14, 1987. Illus.

Jacobs, Mimi. "Conjugal Art." *Pacific Sun* (Mill Valley, CA), Nov. 15–21, 1973, pp. 17–18. Illus.

Johnson, Beverly Edna. "Books." *Los Angeles Times*, Dec. 10, 1972, Home Magazine, p. 128. Illus.

Johnson, Rita. "Girl seeing with fresh eyes." *Christian Science Monitor*, Oct. 8, 1975, p. 28. Illus.

Kapp, Joellyn. "The Stanford Woman Speaks." *Stanford Alumni Almanac*, vol. 6, no. 4, Jan. 1968, pp. 6–8. Illus.

Korshak, Brian. "A Collection of Wonderful Things." *Houston Chronicle*, Nov. 19, 1972.

Maupin, John LaLiberte. "Intaglio 'Collection' grows on owner with each viewing." *Idaho State Journal* (Boise), Oct. 20, 1972.

McCann, Cecile N. "A Collection of Wonderful Things." *Artweek* (San Jose, CA), vol. 3, no. 41, Dec. 7, 1972. Illus.

Minor, Denise. "Adams and Van Hoesen—a Marriage of Arts and Minds." *Noe Valley Voice* (San Francisco, CA), Sept. 1995, pp. 19–20.

Morch, Al. "Drawing a very fine line." *San Francisco Examiner*, June 9, 1980, p. 30. Illus.

———. "Five artists drawn together." *San Francisco Examiner*, Jan. 10, 1983, p. B14.

Neville, John. "C. Troup to Exhibit Three from Bay Area." *Dallas Morning News*, Apr. 27, 1966.

"Personal Reflections of a Sensitive Artist." *Los Angeles Times*, Oct. 29, 1967, Home Magazine, pp. 32–33. Illus.

Platt, Susan. "Artists Who Draw." *Artweek* (San Jose, CA), Jan. 29, 1983, p. 5. Illus.

"A Portfolio by Beth Van Hoesen." *Ramparts* (Menlo Park, CA), vol. 3, no. 1, Summer 1964, pp. 41–58.

Roder, Sylvie. "Floating babies and other wonders." *Palo Alto Weekly*, Nov. 16, 1983. Illus.

Scarborough, Jessica. "Mastery of the Commonplace." *Artweek* (San Jose, CA), vol. 14, no. 6, Feb. 12, 1983. Illus.

Schlesinger, Ellen. "Mixing New Ideas, Personal Vision and Humor in Art." *Sacramento Bee*, Jan. 1984. Illus.

"Seeing The World in A Special Way." *Independent Journal* (Marin Co., CA), Nov. 18, 1972, p. M18.

Seldis, Henry J. "Reading the Fine Prints." *Los Angeles Times*, Jan. 29, 1967, Calendar section, p. 34.

Shane, George. "The Visual Arts." *Des Moines Sunday Register*, Sept. 5, 1965. Illus.

Shere, Charles. "Eastbay Becomes a Center for Quality Prints, Etchings." *Oakland Tribune*, June 20, 1976, p. 18-E.

———. "Artists' selves shine through in drawing." *Oakland Tribune*, Jan. 20, 1983. Illus.

"Simple, Recognizable Things Become Art in Her Hands." *San Jose Mercury News*, Dec. 11, 1980.

Snelling, Sharon. "'Creatures' by Beth Van Hoesen." *Sacramento Bee*, Dec. 6, 1987.

Spadfor, Gina. "Animal portraiture leaps to life." *Sacramento Bee*, Mar. 19, 1988. Illus.

Steinberg, Steven. "Beth Van Hoesen: A San Francisco printmaker etches on off-beat cast of characters." *Southwest Art*, Jan. 1985, pp. 63–65. Illus.

Stutzin, Leo. "Art Comes in Twos in 3 Shows." *Modesto Bee* (Modesto, CA), Sept. 13, 1998. Illus.

Tarzan, Deloris. "Prints focus on portraits." *Seattle Times*, Mar. 3, 1974. Illus.

Thompson, Tracie. "Art of seeing animals." *Palo Alto Times*, Jan. 12, 1988, pp. 1, 17. Illus.

Threepenny Review, Spring 1985. Illus.

Tromble, Meredith. "Wild Things." *Artweek*, vol. 24, no. 11, June 3, 1995, p. 4. Illus.

Van Hoesen, Beth. "The Independent Printmaker." *California Society of Printmakers Quarterly Journal*, Apr. 1986.

Walker, Dorothy. "Wife Wins Right to Share Spotlight with Husband." *San Francisco News*, Mar. 10, 1959.

Weaver, Gay M. "Two galleries offer pleasing exhibitions." *Palo Alto Times* (Palo Alto, CA), Dec. 24, 1971, p. 11.

———. "Personal touches to common images." *Palo Alto Times* (Palo Alto, CA), May 1977.

Weeks, H. J. "Quietly Elegant Exhibition of 3 Art Colleagues' Works." *San Jose Mercury*, June 3, 1977.

Weisser, Peter. "Crocker's Four-Artist Show." *Sacramento Bee*, Oct. 30, 1966, p. L12–13. Illus.

Wilson, William. "'Nude Man' Dignified in Etching Exhibition." *Los Angeles Times*, Sept. 23, 1966.

Winter, David. "Beth Van Hoesen: John Berggruen." *ARTnews*, vol. 84, no. 9, Nov. 1985, pp. 130–31. Illus.

Yuna, Joelle. "Van Hoesen/Adams." *WestArt*, Aug. 3, 1973. Illus.

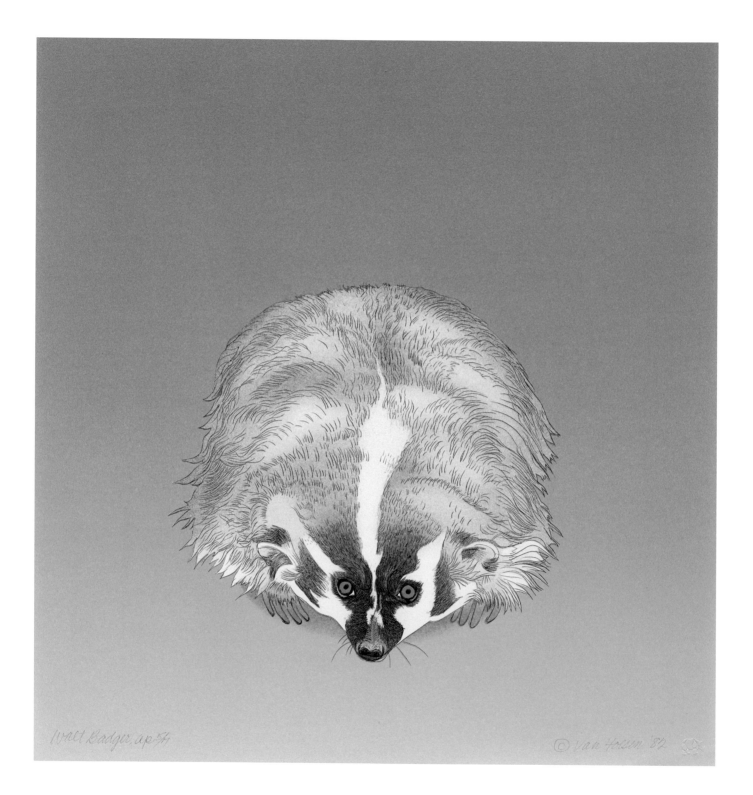

Selected Collections

Achenbach Foundation for Graphic Arts, Fine Arts Museums of San Francisco, San Francisco, CA

Art Gallery, San Francisco State University, San Francisco, CA

Art Institute of Chicago, Chicago, IL

ASU Art Museum, Arizona State University, Tempe, AZ

Block Museum of Art, Northwestern University, Chicago, IL

Boise Art Museum, Boise, ID

Brooklyn Museum, Brooklyn, NY

Cincinnati Art Museum, Cincinnati, OH

City and County of San Francisco, CA

De Saisset Museum, Santa Clara University, Santa Clara, CA

El Paso Museum of Art, El Paso, TX

Fresno Art Museum, Fresno, CA

Honolulu Academy of the Arts, Honolulu, HI

Illinois Bell Telephone Company, Chicago, IL

Iowa State University, University Museums, Ames, IA

Mills College, Oakland, CA

Monterey Peninsula Museum of Art, Monterey, CA

Museum of Modern Art, New York, NY

National Collection of Fine Arts, Smithsonian Institution, Washington, DC

Norton Simon Museum, Pasadena, CA

The Oakland Museum, Oakland, CA

Oakland Public Library, Oakland, CA

Portland Art Museum, Portland, OR

Rutgers University Printmaking Studies Archives, New Brunswick, NJ

Sacramento Public Library, Sacramento, CA

San Francisco Museum of Modern Art, San Francisco, CA

San Jose Museum of Art, San Jose, CA

Santa Barbara Museum of Art, Santa Barbara, CA

Stanford University, Stanford, CA

Syracuse University Art Galleries, Syracuse, NY

Triton Museum of Art, Santa Clara, CA

U.S. Information Agency, Washington, DC

University of California Berkeley Art Museum, Berkeley, CA

University of California Davis, Richard L. Nelson Gallery, Davis, CA

University of Idaho, Department of Art and Architecture, Moscow, ID

University of Tennessee, Chattanooga, TN

Victoria and Albert Museum, London, UK

Williams College, Williamstown, MA

This publication accompanies an exhibition at the Fresno Art
Museum, California, November 20, 2009–January 10, 2010.
The exhibition will travel to the University Museums, Iowa State
University, Ames, and other venues.

The Foreword by Robert Flynn Johnson first appeared in the
catalogue *Beth Van Hoesen,* published by The Art Museum
Association, 1983.

A version of Bob Hicks's essay appeared in *The Oregonian*
(Portland), May 8, 2009.

Library of Congress Control Number: 2009939624
ISBN: 978-0-932325-93-8

Catalogue concept, research, and project coordination by
Anne Kohs & Associates, Inc., Portola Valley, California.

Edited by Lorna Price and Diane Roby
Designed by John Hubbard
Typeset by Marissa Meyer in Arno Pro
Color management by iocolor, Seattle
Produced by Marquand Books, Inc., Seattle
 www.marquand.com
Printed in Canada by Hemlock Printers Ltd.

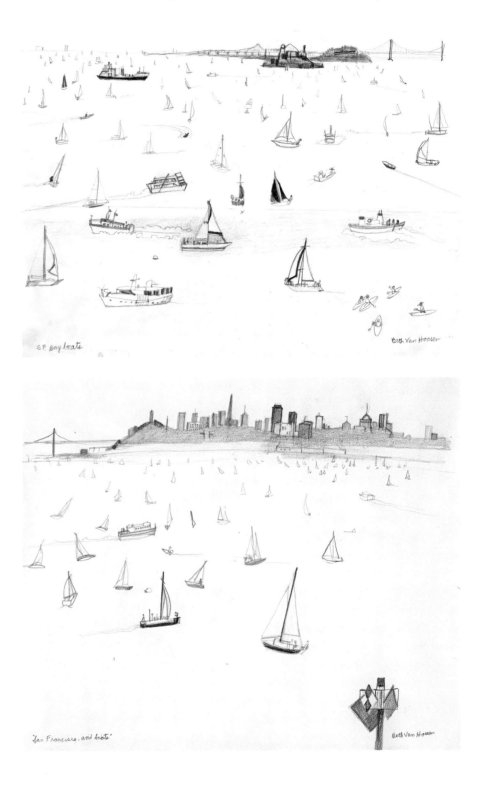

S.F. Bay boats

Beth Van Hoosen

'San Francisco and boats'

Beth Van Hoosen